Chagall
Watercolors
and
Gouaches

Chagall Watercolors and Gouaches

by Alfred Werner

WATSON-GUPTILL PUBLICATIONS, NEW YORK

First published 1970 in New York
by Watson-Guptill Publications,
a division of Billboard Publications, Inc.,
165 West 46th Street, New York, N.Y.
All rights reserved.
No portion of the contents of this book may be reproduced
or used in any form or by any means without the written
permission of the publishers.
Manufactured in Japan
ISBN 0-8230-0600-X
Library of Congress Catalog Card Number: 70-128-389

To Judith

COOPERATING MUSEUMS

I would like to thank the staffs of the following sixteen American museums and galleries, and the following private collectors, who supplied me with basic scholarly data and who made available their color transparencies— many of which were shot especially for this book.

Acquavella Galleries

Albright-Knox Art Gallery

The Baltimore Museum of Art

Blanden Memorial Art Gallery

La Boetie, Inc.

City Art Museum of St. Louis

The Detroit Institute of Arts

Mr. Victor Hammer

Los Angeles County Museum of Art

Museum of Modern Art

Perls Galleries

Philadelphia Museum of Art

The Phillips Collection

Pierre Matisse Galleries

Mr. James J. Shapiro

Mr. and Mrs. Henry Sieger

The Solomon R. Guggenheim Museum

Stephen Hahn Gallery

Mr. Herbert H. Strauss

Worcester Art Museum (The Dial Collection)

LIST OF ILLUSTRATIONS

CHRONOLOGY

1887. Born in Vitebsk, White Russia, on July 7, the eldest of nine children of Zahar Segal (Chagal), laborer in a herring packing plant, and his wife Feige-Ita.

1906. Studies at the local school of art, run by Yehuda Pen. Apprenticed as a retoucher to a photographer.

1907. Travels to St. Petersburg with a classmate. Awarded scholarship by art school sponsored by the Imperial Society for the Protection of the Arts.

1908. Studies at a private school directed by Savel M. Saidenberg; then with Léon Bakst at the progressive Svanseva School. Paints his first important oil, *The Dead Man.*

1909. On a visit home, meets Bella Rosenfeld, daughter of a well-to-do Vitebsk jeweler.

1910. Departs for Paris. Changes spelling of name to Chagall.

1911. Moves to *La Ruche,* a large studio building in St. Petersburg occupied by young artists.

1912. Participates in the Salon des Indépendants and the Salon d'Automne. Meets Blaise Cendrars and other writers.

1913. Exhibits three pictures at the First German Autumn Salon in Berlin, organized by Herwarth Walden.

1914. First one man show at Walden's Sturm Gallery, Berlin. Travels to Berlin, then to Vitebsk where he is caught by the outbreak of World War I.

1915. Exhibits at the Mikhailova Art Salon, Moscow. Marries Bella Rosenfeld. Mobilized into Russian army.

1916. Birth of Chagall's daughter, Ida.

1917. Exhibits at Petrograd. Due to the Bolshevik Revolution, he acquires full rights of citizenship which the Tsarist regime had withheld from all Jews in Russia.

1918. Appointed Fine Arts Commissar for the province of Vitebsk. Organizes the celebrations for the first anniversary of the October Revolution. First monograph on Chagall, by Abraham M. Efross and Jakob A. Tugenhold, published in Moscow.

1919. Directs a Free Academy of Art at Vitebsk, but resigns the directorship after a quarrel with the Suprematist artists' group. Participates in the First State Exhibition of Revolutionary Art at the Petrograd Palace of Art. (One room is reserved there for his works, which are acquired by the State.)

1920. Moves to Moscow where he designs stage sets and costumes for theaters, and executes murals for the Chamber State Jewish Theater.

1921. Teaches art at two War Orphans Colonies outside Moscow.

1922. Autobiography, *My Life,* completed. With the help of Anatoly V. Lunarcharsky, Commissioner of Education, obtains a passport and goes to Kovno (Kaunas), where he holds an exhibition. Leaves for Berlin where he is subsequently joined by wife and daughter. The dealer, Paul Cassirer, plans to publish an illustrated edition of *My Life* in German translation, but eventually only Chagall's etchings are issued in a portfolio without the text.

1923. Moves to Paris, shortly to be joined there by his family. Commissioned by the dealer, Ambroise Vollard, to make etchings for an edition of Gogol's *Dead Souls,* completed by 1927, but not published until 1948.

1924. First retrospective exhibition at the Galerie Barbazanges-Hodebert in Paris. Stays at the island Bréhet, off the coast of Brittany.

1926. First one-man show in the United States at the Reinhardt Galleries, New York.

1927. Commissioned by Vollard to illustrate an edition of *The Fables of La Fontaine.* Prepares sketches in gouache, and then etchings in black-and-white. Etchings not published until 1952.

1930. Attends opening of his exhibition at Berlin's Galerie Flechtheim.

1931. Autobiography published in French *(Ma Vie).* Commissioned by Vollard to do etchings for an illustrated edition of the Old Testament; travels to the Middle East to prepare for the task. Accompanied by wife and daughter, visits Palestine and attends the opening of the museum in Tel-Aviv. Also visits Lebanon and Egypt. Bible etchings remain unpublished until 1957.

1932. Travels to Holland and sees Rembrandt's paintings for the first time.

1933. Large retrospective exhibition at the Kunsthalle, Basel, Switzerland.

1934. Journeys to Spain and sees El Greco's paintings.

1935. Journeys to Poland.

1937. Becomes a French citizen. Journeys to Italy. Several of his pictures were among the works selected by the Nazis for the "Degenerate Art" exhibition in Munich.

1938. Exhibits in Brussels.

1939. Awarded the Carnegie Prize for the painting, *The Red Wing*.

1940. France surrenders to the Nazis. Chagall and his family are at Gordes, a village in Provençe, Unoccupied France.

1941. The Chagalls move to Marseilles. Invited by the Museum of Modern Art, New York, they travel to the United States and arrive there on June 23, the very day on which German armies invade Russia.

1942. Commissioned by the Metropolitan Opera in New York to do sets for the ballet *Aleko*. Work executed in Mexico City, where the first performance is given by the American Ballet Theatre.

1944. Death of Bella Chagall.

1945. Designs sets and costumes for the Metropolitan Opera ballet, *The Firebird*.

1946. Large retrospective show at the Museum of Modern Art, New York, subsequently seen at the Art Institute of Chicago. Makes first postwar journey to Paris.

1947. Revisits Paris for the opening of his retrospective at the Musée Nationale d'Art Moderne. Retrospective at the Municipal Museum, Amsterdam.

1948. Returns to live in France at Orgeval, near Saint-Germain-en-Laye, just outside Paris. At the 24th Biennale, Venice, a room in the French Pavilion is devoted to Chagall; awarded the Biennale's first prize for graphic art.

1949. Sojourn at Saint-Jean-Cap-Ferrat, on the French Riviera. Completes murals for the foyer of the Watergate Theatre, London. Meets Elie Tériade, future publisher of cycles of Chagall's prints.

1950. Buys a villa at Vence, near Nice. Illustrates Boccaccio's *Decameron* for the magazine *Verve*. Works in ceramics. Retrospective show at the Kunsthaus, Zurich, later transferred to the Kunsthalle, Bern.

1951. Journeys to Israel and completes his first sculpture.

1952. Marries Vava Brodsky. Journeys to Greece.

1954. Second journey to Greece.

1955. Exhibits at the Kestner Museum, Hanover. Works on lithographs for *Daphnis and Chloe* (to be published in 1961). Completes ceramic mural, marble reliefs, and other works for the church Nôtre-Dame-de-Toute-Grace on the Plateau d'Assy, in the French Alps. Starts series of pictures on Biblical themes. Prepares a series of lithographs on circus theme.

1957. Journeys to Israel to attend the opening of the *Chagall House* at Haifa.

1959. Awarded an honorary membership by the American Academy of Arts and Letters. Degree of Doctor Honoris Causa conferred by the University of Glasgow. Starts designing stained glass windows for the Cathedral at Metz, France.

1960. Shares the Erasmus Prize with Oskar Kokoschka, awarded by the European Foundation for Culture in Copenhagen. Degree of Doctor Honoris Causa conferred by Brandeis University, Waltham, Massachusetts. Autobiography published in English (*My Life*).

1961. Designs stained glass windows for the synagogue of the Hadassah Medical Center near Jerusalem.

1961. Journeys to Israel for the installation of the windows. Made honorary citizen of Vence.

1963. Journeys to Washington, D.C., to address Congress on behalf of the Center for Human Understanding. Retrospective shows at Tokyo and Kyoto, Japan.

1964. Unveiling of his ceiling painting for the Paris Opera, commissioned by the Minister of Culture, André Malraux. Completes murals for the Grand Auditorium in Tokyo. Journeys to New York where he designs windows in memory of Dag Hamarskjöld for the United Nations and for the church of Pocantico Hills, New York, in memory of John D. Rockefeller, Jr.

1965. Creates lithographs on the *Exodus* theme. Receives honorary degree from the University of Notre Dame, Indiana. Made officer of the Legion of Honor.

1966. Journeys to New York for the unveiling of two murals for Lincoln Center. Creates twelve mosaic panels for the walls of the Knesset, the Parliament in Jerusalem. Leaves Vence to settle in nearby Saint-Paul-de-Vence.

1967. Journeys to New York to attend the première of a new production of Mozart's *Magic Flute,* for which he designed the stage sets and costumes. Works on designs for a large tapestry for the Knesset. 80th birthday is celebrated by large retrospectives at Zurich and Cologne museums. Sketches for *Aleko* exhibited at the Museum of Modern Art, New York. *Message Biblique* exhibition at the Louvre, Paris. Receives Cross of the Order of Merit.

1968. Journeys to Washington, D.C. Designs mosaic for the University of Nice.

1969. Foundation stone laid for the Chagall Museum at Nice. Journeys to Israel for the installation of the Knesset tapestry.

1970. Retrospective exhibition at the Grand Palais, Paris. Works on designs for stained glass windows to be installed in the Frauenmuenster Cathedral in Zurich, Switzerland.

BIBLIOGRAPHY

Ayrton, Michael. *Chagall.* Faber and Faber, London, 1961.

Brion, Marcel. *Marc Chagall.* Harry N. Abrams, Inc., New York, 1961.

Cain, Julien. *The Lithographs of Chagall.* George Braziller, Inc., New York, 1960.

Cassou, Jean. *Chagall.* Frederick A. Praeger, Inc., New York, 1965.

Chagall, Marc. *My Life.* Orion Press, New York, 1960.

Chagall, Marc. *Drawings for the Bible.* Harcourt, Brace & World, Inc., New York, 1960.

Cogniat, Raymond. *Chagall.* Crown Publishers, Inc., New York, 1965.

Erben, Walter. *Marc Chagall.* Frederick A. Praeger, Inc., New York, 1966.

Foster, Joseph K. *Marc Chagall: Posters and Personality.* Reynal & Co., New York, 1966.

Freund, Miriam. *Jewels for a Crown.* McGraw-Hill Book Company, New York, 1963.

Kloomok, Isaac. *Marc Chagall: His Life and Work.* Philosophical Library, Inc., New York, 1951.

Lassaigne, Jacques. *Marc Chagall: The Ceiling of the Paris Opera.* Frederick A. Praeger, Inc., New York, 1966.

Lassaigne, Jacques. *Chagall: Unpublished Drawings.* Skira Art Books, New York, 1968.

Lassaigne, Jacques. *Marc Chagall: Drawings and Watercolors for the Ballet.* Tudor Publishing Company, New York, 1969.

Leymarie, Jean. *The Jerusalem Windows.* George Braziller, Inc., New York, 1967.

McMullen, Roy and Izis. *The World of Marc Chagall.* Doubleday & Company, Inc., New York, 1968.

Meyer, Franz. *Marc Chagall.* Harry N. Abrams, Inc., New York, 1961.

Meyer, Franz. *Marc Chagall: His Graphic Work.* Harry N. Abrams, Inc., New York, 1957.

San Lazzaro, Gino di, ed. *Hommage a Chagall.* Tudor Publishing Company, New York, 1969.

Sweeney, James J. *Marc Chagall.* Museum of Modern Art: Publications in Reprint Series, 1946.

Venturi, Lionello. *Chagall.* Skira Art Books, New York, 1956.

Wahl, Jean. *Illustrations for the Bible.* Harcourt, Brace & World, Inc., New York, 1956.

Werner, Alfred. *Chagall.* Tudor Publishing Company, New York, 1967.

Werner, Alfred. *Chagall.* McGraw-Hill Book Company, New York, 1969.

MARC CHAGALL's story is too widely known to need any extended treatment here. For an account of his first thirty-five years, there is no more informative work than his autobiography, available in English since 1960 under the title, *My Life.* In a poetic, staccato style, the author deals with his youth at Vitebsk (1887-1907); with his subsequent three years of study at St. Petersburg, interrupted by lengthy vacations in his native town; the first Parisian period, from 1910 until the spring of 1914; and the long Russian interlude that terminated in 1922, when the Soviet state had become too uncomfortable for him, and along with other creative persons, he decided to migrate to the greater freedom offered by the West.

The scholar who wants details about a longer stretch of Chagall's personal life will find them, along with a wealth of notes on the master's growth and development as an artist, in the impressive monograph by his son-in-law, Franz Meyer. Its nearly 800 pages cover everything important up to the year of its publication, 1963. A good deal about him—his grand style of life in Paris or on the Riviera, his wide travels, his fascinations and foibles—has become known to the public through his many witty and charming interviews. A cover story in *Time* magazine reached millions who do not ordinarily read about art and artists.

Chagall's experiences, however, are devoid of the stark drama that characterized the lives of the two post-Impressionists, Gauguin and Van Gogh, who exerted a deep influence upon him. He underwent periods of poverty during the early part of his career, and in the beginning there was a hostile reaction to his work on the part of public and press alike. By and large, however, save for the premature death of his first wife, Bella, the tragic element is absent from his life. He was able to weather the Nazi period as a rather pampered refugee in New York City and thereafter returned to his beloved France, where he received a hero's welcome. Unlike so many artists who reap recognition and wealth only when they are too old to enjoy either, Chagall, long before he had turned fifty, received all the attention any man could crave. Apart from these accolades, his life has been "uneventful"—unless one considers each creation of a masterpiece a major event. Today, in public recognition, the *maître* of Saint-Paul-de-Vence is second only to Pablo Picasso among living artists, and his fame is of a kind usually allotted to statesmen or astronauts.

During the last few years in the United States, Chagall has become a name that symbolizes fantasy, color, and joy. Currently, he is one of the best known of all *Ecole de Paris* artists. Color reproductions of some of his early oils keep on selling as briskly as those of works by Van Gogh, Matisse, or Picasso. Every season a new book on Chagall appears in English, and his more recent works are displayed regularly in New York by his steadfast dealers, Pierre Matisse and Klaus Perls. Whatever reservations some critics may have about the creations of his old age, and even about his stature in the world of art, he is loved by the public at large.

At any rate, Chagall's work has a secure place in America today. When his twelve stained glass windows were displayed at the Museum of Modern Art in New York before their final installation at the synagogue of the Hadassah Medical Center near Jerusalem, they attracted crowds that lined up on 53rd Street for half a mile. Some of this popularity stems from the fact that a considerable segment of New York's Jewish population feels a kind of ethnic pride in his success. A number of people in this group equate his work with the musical, *Fiddler on the Roof,* although his pictorial renderings of Uncle Neuch, perched on the roof of an *izba,* antedate the Broadway success by several decades. It is too simple to focus on the "obvious," easily comprehended side of the artist's achievements and to lose sight of their inherent poetry. Those born in the Old Country often love him for his subject matter alone (the bearded rabbis and village musicians), although they may wince at the green faces and flying cows. To the young, however—especially the smart, college-educated suburban housewives—Chagall is sufficiently modern to be given a place among the most advanced abstractionists, while his "Jewishness" is quaint and unrealistic enough to remove the stigma of chauvinism.

This is certainly a happy reversal of the reception given to the first of Chagall's shows to cross the Atlantic. His exhibition at New York's Reinhardt Galleries in 1926 was greeted coldly. Critics paid little attention to him. The arch-conservative, Thomas Craven, in *Modern art*—avidly read in the 1930's—classified Chagall among "sorrowing and humorless (sic!) artists." Describing him as "a Russian Jew, who paints jackasses with visions in their heads, and topsy-turvy villages shot through with memories of his childhood," Craven tempered his damnation with faint praise: "His disorderly conceptions would be ridiculous if they did not convey a little of the vagabond poetry and the pathos of his uprooted soul."

As late as 1945, an admirer of Chagall like Lionello Venturi, another victim of Fascism to have found refuge in the United States, and a critic whose acceptance of the artist was wholehearted, confessed pessimism about the welcome his friend's work would receive in this country. In the first book on Chagall in the English language, Professor Venturi wrote: "Unfortunately the public is still slow to admit in painting the same freedom that it readily admits, for example, in even the traditional language of poetry. Time must pass before Chagall's work receives the mature understanding and full recognition it deserves."

The Italian scholar was agreeably surprised only a year later when the large Chagall retrospective show, arranged jointly by New York's Museum of Modern Art and the Art Institute of Chicago, was hailed with enthusiasm and admiration. However, one ingredient—already alluded to before—in this success may have been a factor unrelated to art. By 1946, everybody in the large, and to a considerable degree art-conscious, American-Jewish community was painfully aware that most of the people in Chagall's pictures had perished wretchedly in the Nazis' attempt to exterminate all Jews. "Vitebsk" thus nostalgically recalled a lost world that had been the habitat, not only of young Chagall, but also of many of the parents (and certainly the grandparents) of those who

saw the magnificent spectacle organized by James Johnson Sweeney.

But this was only part of the reason for the show's success; it was also influenced by a maturing of the general American public. To judge by devastating observations made by foreign visitors, from Alexis de Tocqueville to Knut Hamsun, Americans had been loath to accept anything that was not "plain, downright, apprehensible by an ordinary understanding." Everyone knows of the struggles of such unorthodox writers as Herman Melville and Edgar Allan Poe, and of the absence of patrons here for such great romantic painters as Ralph Blakelock and Albert Pinkham Ryder. Surrealism, which made a considerable impact on France in the 1920's and 1930's, almost completely bypassed the United States.

Apparently enough Americans were ready by 1946 to have their materialistic shells pierced by the startling iconography of an artist who confronted them with bird-headed humans and instrument-playing beasts. At any rate, no one objected strongly when Mr. Sweeney of the Museum of Modern Art praised Chagall's attainment as "the reawakening of a poetry of representation, avoiding factual illustration on the one hand and non-figurative abstraction on the other." Many agreed with his further description of Chagall in the catalogue as the artist "who has brought poetry back into painting through subject matter, without any sacrifice of his painter's interest in the picture for itself, and entirely aside from any communication that can be put into words."

A quarter of a century has not invalidated Sweeney's astute analysis of Chagall's graphic world, nor the critic's explanation that the painter "built" his pictures out of elements which appeared disparate, but were actually derived from a whirlpool of recollections in the artist's subconscious mind. Indeed, the elements are drawn in a more or less realistic manner; it is their illogical grouping and arrangement that creates the metaphorical character of his work. The passage of time has not diminished the importance, at one juncture in art history, of Chagall as an innovator and trail-blazer.

Recently, however, there has been some dissent. When his latest drawings and paintings were presented by the Matisse Gallery in 1968 and 1969, some of the critics were wise enough not to expect an octogenarian to provide any surprises, and two or three felt amused, exhilarated, and even touched by his most recent offerings. Others have been less charitable. Resentment of what one might call the "Chagall orgy" has led a few to veer in the opposite direction and to judge Chagall as wrongly as those who worship every scrap of paper carrying his signature (genuine or otherwise). Here and there, he has even been dismissed as one who stopped creating anything of real value after giving the world a small legacy of great pictures.

This is patently untrue. His etchings for the Bible, for instance, are among the most sensitive prints executed in the 1930's. Even now, as a very old man, the master delights us, again and again, with a picture that has charm, delicacy, wit and chromatic splendor—virtues, it is true, that are not too readily acknowledged in our "cool" era.

To be just, a place *must* be found for Chagall somewhere between the pleasing, but parochial, naturalism of an Andrew Wyeth, and the sophisticated, but forbidding rectangles of an Ellsworth Kelly. For Chagall is a naive folk poet, an unashamedly sentimental, romantic, and tender man. This is apparent, I believe, in the thirty-two watercolors and gouaches which I have selected for this book. They were chosen from American collections, public as well as private, to draw attention to some of the most intimate, most spontaneous aspects of his art. They

are likely to find a receptive audience, even in 1970. For Chagall will always speak to people who can set their imagination free and to those who, like him, need to dream.

And to give expression to their dreams! "With Chagall alone . . . metaphor makes its triumphant entry into modern painting," André Breton, spokesman of the Surrealist movement, once wrote. One may quibble about the word "alone," if one remembers, for instance, the oils and watercolors of Redon, which anticipate the fantastic creations of Chagall. However, it is certain that Chagall succeeded, as few others did, in expanding the frontiers of aesthetic perception by creating the most striking symbolic language. Breton should not have said "alone" for the simple reason that every painter, poet, and composer has profited by the research and imagination of those who preceded him. At the same time, every creative person contributes something from his own vast reservoir of inventive strength and leaves the world much richer than before; in this sense, Chagall has expressed new ideals, novel images in an idiom more universal than those of the classroom.

The genius of some artists rests in their ability to invent new techniques rather than concepts. To the Impressionists—the movement was at its peak when Chagall was born—we owe the "spectrum palette." They discovered, or rather rediscovered, the bright, fresh, cheerful colors that had nearly perished under the Academy's addiction to "noble" grays and browns. Yet, admirable as their pictures are, the Impressionists were not really the revolutionaries some Parisian critics pronounced them to be; they developed their methods as the last heirs of the Renaissance progression towards a scientifically accurate representation of nature. They were actually "old-fashioned" realists who painted simply what they saw, or believed they saw. It was left to those who came after them to delve deeply into the unconscious mind, bringing up from that abyss all its anxieties, along with all its joys.

The Impressionists' love for color—but no more than that—was adopted and *adapted* by those who are known as Post-Impressionists, some of whom, like Redon and Gauguin had, at one time, been allied with Monet and his group. The influence of these two, Redon and especially Gauguin, on Chagall is unmistakable. Like them, he was, at one point, a revolutionary. His pictures seemed startling, even shocking, at the Salon des Indépendants of 1911, and, three years later, at the Sturm Gallery in Berlin. However, it does not diminish Chagall's originality and individuality to mention that he was not the earliest to renounce

Before Chagall was born, Baudelaire, the father of modern art criticism, prophetically spoke of a good picture as "a faithful equivalent of the dream which had begotten it," and defined art as "the creation of an evocative magic." The poet had little sympathy for Courbet, arch-exponent of *réalisme,* who had declared that he would paint an angel only if he were shown one, maintaining that imagination in art consisted of finding the most complete expression for an existing thing. (One wonders how the painter of *The Stonebreakers* would have reacted to Chagall's pictures, in which winged beings appear so frequently.) Redon, who came to the fore after both the proto-Surrealist poet and the realist painter had gone, somehow anticipated Chagall by exploring the most fantastic extremes of the boundless realms of the imagination, aided by an eye trained to study nature with great precision. He criticized the Impressionist school largely because its adherents were too submissive before nature, and because they had "too low a ceiling." Challenging these faithful copyists of the external appearance of things, Redon

pleaded for "a right that has been lost and which we must conquer: the right to fantasy. . . ."

Redon's impact is best seen in Chagall's late lithographs. Gauguin, on the other hand, has meant so much to Chagall in every respect that no biographer can overlook his influence. Like Redon, Gauguin complained that Monet and his circle were too addicted to reproducing the skin of nature: "They heed only the eye and neglect the mysterious center of thought." Chagall's early nudes recall Gauguin's South Sea females, and Chagall's sculptures and pottery, all products of his old age, are reminiscent of Gaugin's work in wood and clay. More important, Chagall followed Gauguin in using flat color for its symbolic effect. Chagall first discovered the French master's pictures on his arrival in Paris in 1910. Forty-six years later, he was to paint a *Homage to Gauguin*, based on one of the Tahitian canvases he had just seen in London. "Gauguin exerted a real, lasting influence on Chagall," claims Franz Meyer. "His *oeuvre* is one of the springboards of Chagall's art, for in it Chagall found a determination to enhance with every possible means the symbolic character of a painting." Further, Meyer asserts that to Chagall Gauguin stands for painting as a secret door from without to within.

These references to Redon and Gauguin—to which the names of Rousseau, le Douanier, Matisse, and others might be added—are designed to counteract the stereotyped notion, held by too many, that Chagall is just "the Jewish painter from Vitebsk." This might be true if the artist had remained untouched by the culture of Western Europe, and if his fascination with certain subject matter (based on childhood recollections) indicated a narrow, parochial outlook on life and art. But just as his pictures have their aesthetic sources in a great many realms of civilization, so they have appealed to people from all groups and all generations.

Perhaps nobody knows how popular Chagall is all over the globe better than the postmen of the Riviera hill-town near Nice, where Chagall has a villa, or those of the Ile Saint Louis, in the heart of Paris, where Chagall occupies an apartment in a centuries-old, stately house. In 1967 in particular, they had ample reasons for regretting his popularity, as the mail addressed to the artist was heavier than ever before. Secretaries, as well as Madame Chagall, were kept busy for days opening the letters and parcels that came from all over the world to hail the master on his eightieth birthday.

It is doubtful that much mail came from Russia, not even from the artist's birthplace, Vitebsk, where he had been Commissar of Art for a short time. Chagall wrote in 1922, shortly before his final departure for the West—"Neither Imperial Russia, nor the Russia of the Soviets needs me, they don't understand me, I am a stranger to them"—and the words hold true to this day. His work was outlawed under Stalin and, despite the post-Stalin thaw, it cannot yet be displayed in Russia. However, some of Chagall's finest works from the 1914-1922 period are held there in museum vaults and occasionally—for instance, for the Grand Palais retrospective of 1970—they may be lent out for a show abroad.

Even those who stress the ramified origins—and the universal appeal —of Chagall's art would concede that the artist and his work would have developed in a totally different way had Feige-Ita *Chagal* (as his parents spelled their name) not given birth to Moshko in that particular year in a provincial town far from all art centers. Born in the 1880's, Chagall shared with Spain's Pablo Picasso, Italy's Amedeo Modigliani, Germany's Ernst Ludwig Kirchner, and Austria's Oscar Kokoschka, the ferment of unrest that swept that whole generation. It was an atmos-

phere very different from that of the Impressionists, whose inner peace was reflected by their choice of subject matter: boating on calm rivers, village roads, still lifes with flowers. Vincent van Gogh, who belonged to the intermediate generation, once summed up his basic and fundamental emotions as "joy, sorrow, anger, and fear." In the work of these five painters of our own century, there is much that is melancholy and sad. Among them, only Chagall expressed joy with great frequency; he alone managed to view the world with optimistic eyes. He was spared the agonies of a Modigliani, who perished miserably at the age of thirty-five, and of a Kirchner, who committed suicide in self-imposed exile from his intolerant native country.

In his autobiography, Chagall relates how his confrontation with the works of Gauguin, Van Gogh, and Matisse, which he discovered at Bernheim's Gallery in Paris, had an enormous impact upon him, making him ignore, and finally forget, all the Russian painting he had seen in his native country. He was fascinated by "this revolution of the eye, this circular motion of the colors which, as Cézanne wanted, mingle at once spontaneously and consciously in a ripple of lines, or rule freely, as Matisse shows." The main inspiration, however, came from Gauguin and Van Gogh. *Sabbath* (1910), the first picture he painted in Paris, seems to have been influenced by Van Gogh's *Night Café*. The vehement yellows, reds, and greens, all applied in thick impasto, are also very much Van Gogh's.

Henceforth, Chagall's emphasis was to be on color. Had Gauguin been able to see the revolutionary works Chagall produced between 1910 and 1914, he would, in all likelihood, have approved, for it was he who advised his followers at Pont-Aven: "How do you see this tree? Is it really green? Use green, the most beautiful green on your palette. And that shadow, rather blue? Don't be afraid to paint it as blue as possible."

But Chagall went far beyond Gauguin: he painted faces and hands green, horses red or blue, and used stronger, flat colors. Among those who admired his early work was the editor of an *avant garde* magazine, Riccioto Canudo, who saluted him as the greatest colorist of his time. The poet and critic, Guillaume Apollinaire, called him a "highly gifted colorist," adding, "His art is sensual through and through." (In Chagall's canvas, *Homage to Apollinaire* 1911, tribute is paid to both these intellectuals.)

After his return from Russia to Paris in 1923, Chagall's color lost some of its ferocity. It became more gentle, more subtle, more subdued. Yet at times, there is a reversion to the original forcefulness, to a "primitive" quality that harks back to the young Russian immigrant's harsh vitality. What Lionello Venturi wrote in 1956 holds as true of the artist's early work as it does of that of the octogenarian. "Like Russian icons, they (Chagall's paintings) are brimful of passionate yearnings expressed by color rather than design . . . Chagall is a born colorist. From his earliest to his most recent pictures he has used color in a highly original way for which there are few precedents, except in Byzantine art and Russian icons."

Chagall is not really concerned with the more cerebral problems of painting. All he wants to achieve is, in his words, "good, honest painting." It was in Paris in 1911 when he began to grasp *les valeurs plastiques*. At that moment, he first experienced light; his colors started to lead a life of their own.

Along with the modern masters who helped brighten his palette, Chagall admires certain old masters, such as Masaccio, Rembrandt, and especially Grünewald. Grünewald used his fervent colors to reconcile

men to the tragedy of living, while Chagall's pictures try to spread *joie de vivre*. He is a happy man, a joyous painter. It was not easy for him to dream up all his splendid color. In the milieu where he grew up, there was hardly any vegetation nearby, let alone flowers. It is not surprising, therefore, that in his earliest paintings brown, ochres, dull greens, and sober blues prevail.

In Chagall's work of the twenties and thereafter, the colors are often laid thinly on the ground, and are infinitely softer, more lyrical than in his earlier paintings. However, there is really no drastic change in his work; all that varies is its density and its intensity as the artist is influenced by different feelings, by the mood of time and place. In *Ida at the Window* (1924), all of the arbitrary coloring, the flirtation with Cubism, the allusions to Vitebsk are absent. During this second sojourn in France, Chagall acquired a taste for *la belle peinture* of French tradition, typical of *la douce France* and devoid of the harshness of Slavic barbarity. Because of this, his paint acquires a soft brightness and the brushwork often has a *sfumato* effect.

Although Chagall was never really an Expressionist (he *is* called one in many books) his 1914 show at Berlin's Sturm Gallery made an impact on young German artists and, in particular, on Heinrich Campendonck. Chagall was welcomed in the German capital in 1922 where he encountered his admiring colleagues George Grosz, Karl Hofer, and Ludwig Meidner who described him as "inwardly burning with unrest."

Both Expressionism and Surrealism have claimed Chagall as a forerunner; but pages are also devoted to him in every history of Cubism, although he was not one of the "insiders," but merely took from it what could be usefully incorporated into *la Chagallité*. He could not help being influenced by the new theories and practices of Picasso and Braque, but he refused to be absorbed by them. His own version of Cubism, with easily recognizable subject matter, was different from that of orthodox Cubism, in which the reality of life was whittled down to geometric patterns. Lionello Venturi thus correctly sized up Chagall's "participation" in Analytical Cubism: "As against mathematics and science . . . he set up poetry."

By the same token, Chagall's kinship to Surrealism is only a remote one. In fact, it is altogether a hard task to fit an artist of his importance into a filing system, and really impossible to label him as one would a dried flower or a dead insect. Nevertheless, the impact of his works on one sensitive young poet indeed helped to give birth to the term Surrealism, or at least to an early version of it. In *My Life,* Chagall relates that when Guillaume Apollinaire came to his studio at *La Ruche,* the artist was reluctant to show his works to the "standard bearer of Cubism." At that time, the artist had already completed such fantastic pictures as *To Russia, Asses and Others* (Musée National d'Art Moderne, Paris) and *I and the Village* (Museum of Modern Art, New York). Chagall describes the scene in this way—"Apollinaire sat down. He blushed, swelled out his chest, smiled and murmured: 'Supernatural! . . .'"

It might be best to turn to the master himself to find out about the aesthetic views that have conditioned and influenced his manner of painting. Luckily for us, he has repeatedly expressed himself on the subject in his autobiography:

"Personally I do not think a scientific bent is a good thing for art."

"Impressionism and Cubism are foreign to me."

"Art seems to me to be above all a state of soul. . . ."

"The soul that has reached by itself that level which men call literature, the illogic, is the purest."

"I am not speaking of the old realism, nor of the symbolism-romanticism that has contributed very little; nor of mythology either, nor of any sort of fantasy, but of what, my God?"

"You will say, those schools are merely formal trappings."

"Primitive art already possesses the technical perfection towards which present generations strive, juggling and even falling into stylization."

"I compared these formal trappings with the Pope of Rome, sumptuously garbed, compared to the naked Christ, or the ornate church, to prayer in the open fields."

Supposedly, this is what Chagall told Apollinaire when he came to look at the artist's pictures. What emerges is an anti-intellectual approach by one who unshamefully admits he has no use for concepts. In *My Life,* Chagall has this to say about the teaching at art academies: "I can grasp things only with my instinct. Scholastic theory has no hold whatever on me." In this sense, there is much of the *peintre instinctif* of Henri Rousseau in Chagall. Although, in the course of decades, Chagall has acquired a worldly sophistication that was never to touch the naive man from Laval, and although the Russian Jew had a characteristic prudence which Rousseau totally lacked, both artists were blessed by the sort of "childishness" that, according to Baudelaire, was a requisite of genius. Both had the capacity to be tellers of fairy tales in a world more accustomed to the sound of ticker tape.

More than thirty years after his encounter with Apollinaire, and more than twenty years after he wrote *My Life,* Chagall, as a refugee from Nazism in the United States, again explained his position. In a talk with James Johnson Sweeney, he gave the reasons why he could not possibly be closely allied with any of the artistic groupings that often claimed him for themselves:

". . . I have admired the great Cubists and have profited from Cubism. But . . . to me Cubism seemed to limit pictorial expression unduly. To persist in that I felt was to impoverish one's vocabulary. If the employment of forms not as bare of associations as those the cubists used was to produce 'literary painting,' I was ready to accept the blame for doing so. I felt painting needed a greater freedom than Cubism permitted. I felt somewhat justified, later, when I saw a swing towards Expressionism in Germany and still more so when I saw the birth of Surrealism in the early twenties. But I have always been against the idea of schools and only an admirer of the leaders of schools . . ."

Hence, it is not surprising that when Sweeney asked Chagall whether his work had any relation to Surrealism, the artist gently pointed out what separated him from that movement:

"Surrealism was the latest awakening of a desire to lead art out of the beaten paths of traditional expression . . . In my work from the beginning one can see these very Surrealist elements whose character was definitely underlined in 1912 by Guillaume Apollinaire . . . On my return to Paris in 1922, I was agreeably surprised to find a new artistic group of young men, the Surrealists, rehabilitating to some degree that term of abuse in the period before the war, 'literary painting' . . . But why, thought I, is it necessary to proclaim this would-be automatism? Fantastic or illogical as the construction of my pictures may seem, I would be alarmed to think I had conceived them through an admixture of automatism . . . Everything in art ought to reply to every movement in our blood, to all our being, even our conscious . . . But I am afraid that as a conscious method, automatism engenders automatism . . ."

Chagall, then, is hard to classify anywhere with absolute certainty. But

in old age, he has the satisfaction of knowing that, as a great independent, he has not struggled in vain and that, while movements and fads come and go, his contribution to man's happiness is not likely to be erased.

Of the many who admire Camille Pissarro's pictures, very few know that the artist was of Jewish origin. Histories of art describe his contributions to Impressionism, but hardly ever mention the painter's ethnic roots. His birth is recorded in the rolls of the synagogue at Saint Thomas, Virgin Islands; yet his "Judaism" played as little a role in his art as did his Danish nationality. He spent most of his life in or near Paris and his *Ile de France* landscapes are as "French" as those of Monet or Renoir.

The case of Chagall—the first and, to this date, the only major artist strongly identified with any Jewish culture and specifically with that of Eastern Europe in the final decades of Tsardom—is quite different. Chagall's exuberance, which is so unusual and perhaps even annoying to some, can be traced to a considerable degree to this background. Altogether, there can be no doubt that among twentieth-century artists he is the one most indebted to his birthplace, to his religious background, and to the ethnic lore of his childhood.

Modigliani died with "Cara Italia!" on his lips, and Picasso has remained Spanish to the core despite sixty years of residence in Paris; but there is no vestige of Livorno in the pictures of the one, nor of Málaga in those of the other. To Londoners and Parisians, the expatriate Whistler may have appeared very American, yet the artist became angry upon being reminded of his native Lowell, Massachusetts, and even claimed to have been born in St. Petersburg, Russia. A biography of the eminent *Blauer Reiter* painter August Macke begins, "He was born in Meschede, which played no further role in his life."

By contrast, the enormous impact that Vitebsk and, in particular, its Jewish quarter has had on Chagall cannot be stressed sufficiently. His capital is invested in his childhood; he has managed to make his nostalgic memories last a full lifetime! Chagall is aware how strongly the Jewish milieu of his native Vitebsk has influenced all his work. True, he has scoffed at attempts to appropriate him for nationalism's sake. Firmly believing in the internationality of art and in the brotherhood of all artists, whatever their religious beliefs or ethnic origins, he once explained: "If a painter is Jewish and paints life, how can he help having Jewish elements in his work? But if he is a good painter, there will be more than that. The Jewish element will be there, but his art will tend to approach the universal."

Nevertheless, he himself found no better term of endearment for Paris, which has been his home for decades, than calling it *"Mon second Vitebsk."* Even though Chagall spent only the first twenty years of his life in Vitebsk, plus short periods during World War I and after the Bolshevik Revolution, we must bear in mind that "the child is father of the man." Depth psychology has taught us that character is molded in the childhood years, whether we care to repress our origins or to make the best use of it.

It is obvious that Chagall chose the latter course. Yet the Vitebsk that is conjured up continuously in his paintings and prints, and so fondly recalled in his autobiography, does not seem to quite coincide with actual facts. The White Russian city of less than 50,000 inhabitants, on the railway from Smolensk to Riga, is described in a pre-World War I *Encyclopedia Britannica* as: ". . . an old town, with decaying mansions of the nobility, and dirty Jewish quarters, half of its inhabitants being Jewish."

To Chagall's fond eyes, the same place appeared "simple and eternal, like the buildings in the frescoes of Giotto." To an outsider, the denizens of the ghetto may have seemed shabby and weird, or at best, quaint and droll. These people had a culture of their own which was based on the Judaic tradition and their own language, Yiddish, which is medieval German blended with Hebrew and Slavic. They were only second-class citizens; in subtle and not so subtle ways they were isolated from the Russian Orthodox majority, who ostracized and at times persecuted them. Yet they were Chagall's own people, his relatives, whom he immortalized benevolently in paint; similarly, Yiddish writers like Sholom Aleichem portrayed this same world of hungry saints and fools, scholars and mountebanks, workers and idlers with sympathy and humor.

Though Marc's father, Zahar, was only a laborer in a herring shop, he was steeped in the intricacies of Jewish ritual. The artist described the Sabbath observances of his childhood in his autobiography. More about the Jewish festivals and celebrations that stirred Marc's powers of observation can be learned from *Burning Lights,* the reminiscences of Chagall's first wife, Bella, who was also a native of Vitebsk. What Chagall experienced around him tickled his sense of burlesque and encouraged his tendency to blend the humorous with the tragic.

Most of the Jews of Vitebsk were poor, and none felt comfortable in the oppressive milieu of Russian authoritarianism. To survive, they needed their religion, their separate identity. Unfortunately, this self-contained Jewish civilization also deprived them of aesthetic stimuli. Eastern European Judaism was more fundamentalist than that of the West and it was inimical to the plastic arts; in accordance with the Second Commandment, "Thou shalt not make unto thee any graven image," the depiction of any figure was considered improper by rabbinic authorities. Yet the ordinary Jew went further in his suspicions of any manifestation of painting, let alone sculpture.

Within the context of the ghetto attitudes, it was erratic enough that Marc wanted to become a singer, then a violinist, thereafter a dancer, and finally a poet; one had to be practical, above all, in a culture of poverty. But to become a painter! What induced him (and other artists of the ghetto) to take up pencil and brush remains a mystery. In the paternal home, not even a reproduction could be seen on the walls, and if they were decorated at all, it was with no more than a couple of family photographs. To Marc's parents, "art," if it meant anything, meant something both blasphemous and *meshuggah* (crazy). When Marc approached his mother and confessed that he wanted to be a painter, she told him simply not to bother her. One of his uncles refused to even shake hands with the young "sinner."

In his autobiography, Chagall indicates that, although drawing was taught at the non-sectarian school he attended as a teenager, and he was often busy copying illustrations from magazines, he still had only the fuzziest notion of what was preoccupying him:

"I was familiar with all the street slang and with other, more modest, words in current use.

"But a word as fantastic, as literary, as out of this world as the word 'artist'—yes, perhaps I had heard it, but in my town no one ever pronounced it.

"It was so far removed from us!

"On my own initiative, I'd never have dared to use that word.

"One day a school friend came to see me and, after looking at our bedroom and noticing my sketches on the walls, he exclaimed: 'I say! You're a real artist, arent' you?'

"An artist? What's that? Who's an artist? Is it possible that . . . I, too . . . ?"

Marc's parents hoped to divert the boy by apprenticing him to a photographer, but art had become his obsession. Finally, they yielded. When Marc had learned all he could at the local art school, which was run by a provincial portrait painter named Yehuda Pen, Zahar Chagall even helped his gifted son to go to St. Petersburg. For the ostensible purpose of fetching some merchandise, he secured a permit for Marc to enter the capital—which was ordinarily closed to all Jews except for a few privileged residents and their servants. In addition, he gave his son all the money he could spare—twenty-seven rubles.

It was in this way that Chagall left forever an exclusively Jewish milieu. From this time, he was surrounded by Russians and thereafter by Frenchmen; but in the eyes of the world, he was a Jewish artist—*the* Jewish artist. Truthfully, is there such a thing? Whenever the point is made that ethnic or religious differences play only a small role in art in modern times, someone will demand, "But what about Chagall?"

At first sight, the Jewish motif seems to be omnipresent in Chagall's work; but more careful scrutiny will reveal that lovers, dancers, clowns, acrobats, musicians, and soldiers appear as frequently as bearded rabbis. Yet he is unique among the outstanding artists of Jewish origin born in the last quarter of the 19th century, for one can look in vain for Jewish subject matter in the pictures of Amedeo Modigliani, Jules Pascin, or Chaim Soutine. Still, the notion of an *Ecole Juive* intrigued critics and historians. Writers sought the common denominator among the Jewish immigrants from Southern and Eastern Europe who filled the artist quarters of Montmartre and Montparnasse for the thirty-five years preceding the Nazi occupation of France.

Speaking about this *enclave* in Paris, Werner Haftmann, in *Painting in the Twentieth Century,* has made some acute observations: ". . . an art was created which expressed the sadness of the Jewish race, the deep lyricism of its ancient memories and the treasures of its legends. These painters were less concerned with form than with images and meanings implicit in their backgrounds. Their art reflects nostalgia for a lost homeland, but also the sense of solitude, of helplessness in the face of a remote, hopelessly hidden God, which is so uniquely characteristic of the Jewish mentality . . . The gentle sadness of this art, its poetic exploration of the world of objects, brings to mind the Hasidic legend of the world as a vessel shattered into a million fragments because it was too full of divine love, each fragment becoming a thing which still preserves a spark of God's love. Sometimes it seems as though these painters were looking for the shards of the vessel and the spark of divine love in them. This changed their mode of perception. The eye searched for legend in reality. The result was a dream about reality, expressed in metaphoric images of reality."

This applies more persuasively to Chagall than, say, to Pascin. At any rate, Haftmann deserves credit for mentioning Hasidism. In his autobiography, Chagall refers to some members of his family who were followers of the saintly rebel, Baal Shem Tov. This eighteenth-century revivalist liberated the untutored masses of Jewish people, who were full of metaphysical thirst, from the rigid and often shallow rationalism of the establishment scholars. He taught his people to live in beauty and happiness, and in joy and nearness to God—each man blissfully working, walking, drinking, and loving. He created new relationships between man and reality, man and God, asserting that a "holy spark" was concealed everywhere and in everything. He taught that to live meant to rise from the lowest to the highest existence, and that evil and good were not mutually exclusive qualities, but that both came from God, like the thornbush and the flame: "It is for man to let the thornbush be completely penetrated by the fire. It is for him to bind the lust of the temptation itself to God."

To understand the man who has painted so many roosters crowing for joy, one must try to grasp the essence of Judaism and its most important offshoot, Hasidism. The idea that what God has created is good is not the Baal Shem's original contribution, though it has always been dominant in the Jewish view of life. Misfortunes were regarded as preludes to the manifestation of God's justice. The Jews themselves remained unshaken in their belief that they were God's chosen people and that, however dark the present, eventually the glory of Israel would be universally acknowledged. Pessimism is voiced in some biblical and postbiblical writings, but it is not prevalent in Jewish thought. While evil does exist, it can be fought by anyone who strongly believes in God and His providence.

Chagall's pictures are delightful illustrations of this philosophy. There may be a melancholy or sad quality in his paintings, but the agony of an unlimited despair is never shown. There is a sense of a metaphysical hope in his work, an optimism deeper than that expressed by the platitude about the cloud with the silver lining. When Chagall paints a beggar in snow, there is a fiddle in his hands, and if he sets a mournful rabbi on the canvas, he adds to this representation of sorrow an innocent white cow as a symbol of peace in the universe. If there is a message in his pictures, it must be this: the world has gone topsy-turvy, but it is still a good world; man is essentially good, a sort of grown child who prefers a boisterous carnival atmosphere, come what may.

Schopenhauer, the philosopher of pessimism, would have been shocked. He disliked the Jews just because of their optimism, which he called *rudilos,* nefarious. We can see that Chagall—who probably never read *The World as Will and Idea*—prefers the traditional dogma of the old *Judengasse:* a living dog is better than a dead lion, and sorrow only clouds any communication with God. In fact, without this optimism, the Jews of Vitebsk could never have survived the twofold curse of poverty and pogrom. Chagall's father toiled so hard that when he came home for supper, he fell asleep at the table. The Chagalls raised nine children, of whom Marc was the oldest, and while no one in the family really starved, neither food nor clothing was plentiful. Yet there were other compensations, and among them was the joyfulness of the Jewish festivals, of which Purim—commemorating the rescue of Persian Jewry from an imminent catastrophe—was the gayest.

In Vitebsk itself, there were no outbreaks of violent hostility against Jews, as there were in other Russian cities under Tsar Nicholas II. Yet on his arrival at St. Petersburg, Chagall found out that he was not a Russian. To remain in the metropolis, the young, would-be art student had to resort to a ruse and pretend that he was employed as a footman in the home of a well-to-do Jewish lawyer (one of the few Jews permitted to reside in the city). Nevertheless, when he returned to the capital without a pass, after having visited Vitebsk, he was jailed for almost two weeks.

All these biographical details (and fifty others that might be added) do not, of course, truly explain the phenomenon of Chagall. He appeared like a comet on the horizon, like a strange star. However, it seems plausible that the instability and wretchedness of Jewish existence in Tsarist Russia was more likely to develop a tendency to nostalgic day-dreaming

than the comparative peace and security of the bourgeois merchant home in which Pissarro grew up.

In his study of Chagall's Jewish background, Isaac Kloomok traced the master's "Surrealism" to his youth in Vitebsk: " An imaginative Jewish child, who lived in a poor home, in a wretched street, where the visible world was miserable and colorless, without joy and without beauty, did not have far to go to escape his unacceptable surroundings. Not far away from his bed and his table lay the path to an infinitely rich and bountiful super-terrestrial world—a free world, with no boundaries and no barriers, a world into which he was carried away by the breath of his whole community in the hours of great festivity. The Jewish child began in infancy to learn the path of escape from the unrewarding world of reality."

One must bear in mind though, that this escapism is not an exclusive trait of the "Jewish" artist. In a sense, all creative people are alienated outsiders in a society that is unhospitable and, at times, even hostile to them. Hence, what Haftmann called "nostalgia for a lost homeland" can also be found in the metaphors of so many non-Jewish artists who are appalled by the phenomena of a mechanized, materialistic age. *Maerchen*, or fairly-tale elements, clearly dominate the pre-abstract oils of Kandinsky, many of the works of Klee, and all the grotesqueries of Feininger and Kubin. However, in Chagall and some of his coreligionists, there is a recognizably greater need to look for "the shards of the vessel," for the "legend hidden in reality." The plight of the Jew was worse than that of his non-Jewish colleague, who at least was left to live unmolested by racial or religious prejudice.

It is not surprising, therefore, that the *Ecole Juive* was in the forefront of the two major anti-naturalistic movements in modern art, Expressionism and Surrealism. Both of these reject the imitation of the drab and unfriendly outer world of reality and render an inner world of feeling, of imagination. Indeed, what is "Jewish" and, at the same time, universal about Chagall's art is his early and peculiar combination of "Surrealism" with "Expressionism," rather than the preponderance of Jewish subject matter. The word "Surrealist" is to be used with caution since neither in his practice nor in his outlook does Chagall quite fit the philosophy expounded by André Breton, and carried out by his associates.

Chagall became the dreamer that he is—*My Life* is filled with records of dreams, and so is his painterly work—largely by force of circumstance. "Were I not a Jew (with the meaning that I put in the word) I would not be an artist at all, or I would be someone else altogether," he once said. This must be amended to read, "Were I not Marc Chagall, a son of proletarian Jewish parents, born and raised in the ghetto slums of Vitebsk under the terror of the last Romanoff, etc." His art constitutes a conscious flight from the reality of Vitebsk into unreality. One is reminded of James Joyce, who set all his stories in Dublin, though his creative freedom actually blossomed only after he had put a distance between himself and his not altogether hospitable native city. Chagall himself once observed that although he was far from home, he was actually nearer to it than many who still lived there.

One might emphasize that his background was that of the proletarian Jews of Eastern Europe; he does not speak for the few middle-class Jews who lived, with little contact with the masses, in most of the major cities of the far-flung Tsarst Empire. Invariably, the Jews whom Chagall painted were the hewers of wood and drawers of water, the cattle-dealers, butchers, petty shopkeepers, itinerant preachers, and folk-musicians. These were not rich people like his in-laws, the Rosenfelds, who owned three jewelry shops in Vitebsk, lived in a fine house near the cathedral, and sent their daughter, Bella—the artist's future wife—to study in Moscow at one of the best girls' schools. Significantly, Bella, as painted by her husband, with her fine clothes and poised bearing, represents a sophisticated class far superior to the artist's.

Chagall is devoid of higher Jewish education. His work reveals no debt to the Cabalah, or to the theological writings. Yet he picked up the folklore, the proverbs, and common sayings that were spread among the masses through the Yiddish language. While the lower class Jews were not illiterate, as were the peasants with whom they traded, their sociological status was similar to that of the Byelorussian *muzhiks*. Chagall himself, with his humor, verve, and vitality, seems to have much in common with the drinking and carousing Russian soldiers who so often turn up in his early works.

As a matter of fact, more attention might be paid to the Russian sources of his art. Despite his orthodox Jewish background and his minority status, he did attend a Russian school in Vitebsk and he did study art in St. Petersburg. He saw and admired the collection of old Russian icons in one museum. He did associate with the somewhat older Mikhail Larionov (who included three pictures by Chagall in a Moscow group show of 1913), and he sympathized with the "Neo-Primitives"— Larionov, Gontcharova, the brothers Burlyuk, and others—rediscoverers of Russia's indigenous culture, a defiantly anti-Academy and anti-establishment group. Like them, he had eyes for the work of the humble ex-serfs, for the carved figurines, the brocades and embroidered carpets which were produced by anonymous craftsmen among people who lavishly adorned the simplest utensil.

His pictures also mirror the gay shop signs in villages where the wares for sale had to be described graphically for the almost completely illiterate population. He saw the glazed polychrome pottery, the decorative tiles, and the embroideries made by the womenfolk during the long winter nights. He looked at the *lubki,* crude but effective graphics for the enjoyment and instruction of the peasantry, which were closely akin to both the *images d'Epinal* that so fascinated many nineteenth-century French artists and to the illustrations of English and American broadsides.

In short, much in the art of Chagall can be traced to these kinds of aesthetic experiences which were entirely outside the "ghetto." The crude vehemence of color, the intensely Slavic humor, the indifference to perspective and traditional modeling, the ornamental rhythm, and the flat, decorative treatment of spatial relationships are all qualities particularly conspicuous in the pictures he painted between 1908 and 1923 —and these are Slavic, rather than Jewish characteristics. To find something parallel to Chagall's Neo-Primitive pictures, one must turn not to the melancholy Hebrew synagogue chant, but rather to the music of his compatriot and contemporary, Igor Stravinsky. Stravinsky's *Firebird*— for which Chagall was to design décor—as well as *Petrushka* and *Rite of Spring* are hallucinatory, harsh, tumultuous, shrill, and also, in some passages, as sentimental or humorous as many of Chagall's very Russian works.

It has often been said that Chagall's strongest pictures are those he painted before he finally left Russia in 1922, and that the blandishments of French culture diluted, and even weakened, his art. In truth, his pictures became softer, more lyrical, and more sophisticated through the artist's daily exposure to Paris and its elegant, witty culture. But French

critics and connoisseurs took many years to even grow accustomed to the work he did in France, work that they felt to be so unclassical, anti-traditional, and barbaric as to violate Gallic taste and sensibility.

Had Chagall remained in Russia, he would soon have felt the iron fist of Stalinism, as many others did, including another scion of the Ghetto, El Lissitzky. Lissitzky was self-exiled in Germany; when he returned to his native country, the regime employed him as a commercial designer, disregarding his great talent as an artist. Or Chagall might have been one of the Russian millions who were martyred by the Nazi invaders during World War II. Thus, Chagall's immigration to France—and his temporary refuge in the United States during the German occupation—saved him as an artist, as well as a person. A Chagall emerged who was primarily Jewish, but also Russian and French; in the final analysis, he had become a world citizen in the realm of art.

Perhaps it may be helpful here to explain the distinction between watercolor and gouache. Watercolor is simply a paste made of powdered pigment or dye compounded with a water soluble glue—usually gum arabic—which can then be diluted with water to a fluid consistency. A painting in watercolor is transparent, allowing the underlying paper to shine through. One layer of transparent color can be applied over another, like layer upon layer of colored glass. Gouache, on the other hand, also consists of pigment or dye, plus a water soluble glue, but also contains a chalky substance that makes the paint opaque. Even when thinned with water, the paint tends to conceal the underlying paper, and one color *covers* another, either partially or completely. Both media are casual and spontaneous, but watercolor tends to be luminous and transparent, while gouache tends to be more solid in tone, a bit more like oil paint.

There are artists who are content to work exclusively in one medium. Chaim Soutine, for instance, confined himself strictly to working in oils. On the other hand, there is hardly a technique that has not been explored by Pablo Picasso. Like the Spaniard, Chagall has applied himself to virtually every facet of image making. While he is chiefly known and rightly famous for his oils, he is eminent as a printmaker; he has also engaged in the creation of sculpture and ceramics; and he has earned distinction for his stained glass windows.

As a watercolorist, Chagall is perhaps not as well known as Signac, Dufy, Nolde, or Klee. Yet he has painted thousands of watercolors and gouaches throughout his long career. If they are not as celebrated as his oils, it is not due to a lack of quality, but rather to the fact that even the largest of them are much smaller than his oils; visitors to his exhibitions are inevitably drawn to the more conspicuous objects. Chagall loves this modest medium for its flexibility and convenience. A watercolorist needs only a sheet of paper, a small paintbox, and a couple of brushes to capture any vista or inner image. A man as spontaneous, as volatile as Chagall can exploit and make the most of a swift vehicle to catch moods that could never be recorded by slower methods of painting. In addition to speed of execution, the limitation of size also rules out unnecessary and laborious detail that would restrict the artist's freedom of expression.

Just as watercolors were useful for the Impressionist who sought to catch in a quick sketch the rapidly changing, rapidly vanishing aspects of a segment of nature, so Chagall, the non-Impressionist, turns to watercolors and gouaches to set down, with immediacy, the inner landscape visions that preoccupy or delight him. These works can be mere notations, comparable perhaps to a writer scribbling a few unrelated words, meaningless to the outsider, but in fact the nuclei of future poems, novels, or plays. At other times, they are well developed pictures, sufficiently "finished" to be chosen by the artist for his museum shows, such as the recent Grand Palais exhibition in Paris. But even the least developed sketches of an artist are often welcomed by connoisseurs who can see the master at work in them; they can, in a sense, look over his shoulder, observe him as he is struck by an idea, as he follows a thought, then changes his mind.

Chagall has been reluctant to release undeveloped pictorial notations. They have too tentative a character, or are, perhaps, too personal. But the more or less "complete" pictures, like the ones chosen especially for this book, are "dialogues" with the spectator. Referring to Chagall's many gouaches, Franz Meyer has written: "They enable us to follow more closely the course of his formal development, which in the oils often seems spasmodic. And it is in the gouaches, too, that the themes for his large works sometimes found their first provisional formulation."

In an analysis of the gouaches Chagall painted during his first Parisian stay (1910-1914), Meyer added: "A few gouaches with Russian themes contrast in their wild, spontaneous handling with the painterly discipline of the studio pictures and at the same time prepare the way for the next series."

The present book contains a selection of both transparent watercolors and opaque gouaches. Since this is the first book devoted to this aspect of Chagall's work, it will, hopefully, fill a gap. Yet these thirty-two pictures constitute only a small segment of his *oeuvre* in these media, and they are all works in American private and public collections. The relative neglect of watercolors in other books about Chagall may be due to the general overestimation of oil paintings. Despite all the glorious evidence to the contrary, watercolors were, for decades, associated by the public mainly with Victorian ladies whiling away their time. This has created a prejudice, a misconception. A watercolor, whatever its qualities, still sells for much less than an oil of no greater merit by the same artist.

This tradition of the market is, of course, absurd. Some of the greatest masters of the past, including Dürer, Rubens, and Van Dyck, used watercolors. Who can deny that William Blake's watercolors on Biblical themes are far more moving and compelling than so many of the huge, theatrical canvases that filled the nineteenth-century salons! Many celebrated modern artists have, at least occasionally, tried their hand at watercolor or gouache. In America there have been many fine watercolorists, among whom Winslow Homer, John Singer Sargent, John Marin, Edward Hopper, Charles Demuth, Georgia O'Keeffe, William Zorach, and Charles Burchfield deserve to be mentioned. It is rare to find an artist who would regard watercolors as a "lesser medium" which is suitable only for preparatory sketches for larger works, and of no interest outside the atelier.

It is true, however, that in Chagall's work there are two kinds of watercolors: those that have served as explorations and rehearsals for a work in oils, and those that have no connection with any existing canvas. Both kinds are important. Watercolor and gouache allow Chagall to experiment, to study details, to draft the main structure that will determine the forms of the more ambitious, larger work he intends to create. But in addition to the watercolors and gouaches to which an auxiliary role is assigned, there are others which present his vision in its complete and final form. All these "studies" are permeated with a spontaneity, a liveliness that often makes them as valuable as the oil paintings. At

times they are even more interesting, as they are devoid of the inhibitions and the afterthoughts that frequently affect pictures that are designed either to hang in exhibition halls or to adorn the homes of rich collectors and, hopefully, to find a permanent place in a museum. For watercolors and gouaches are never doodles; they are works fully achieved and perfected. If they are related to an oil, they compare to it somewhat the way a dance theme becomes a scherzo in a symphony.

Chagall's watercolors are excellent examples of the master's cursive virtuosity, that suggests rather than describes, that seems so light, swift, graceful, and apparently effortless that one forgets the years of practice and study behind it. Pure watercolor, in particular, is very difficult and challenging. Among painting media, it is the most elusive and, therefore, the most demanding of all. It calls for the utmost spontaneity of vision and swiftness of work. If one stroke is misplaced, the artist might just as well abandon the picture; unlike an oil, or even a gouache, a transparent watercolor cannot be corrected or worked over.

Opaque watercolor (or gouache) is easier to handle than transparent watercolor because in the gouache technique, one layer of color covers the other, and the artist is free to change his mind. It is not too difficult for the layman to distinguish a gouache from a pure watercolor. In the latter, the sparkling brightness of the paper always plays an important part; the white paper ground is often visible through the colors themselves, and white areas of paper are often deliberately left unpainted. Although gouache lacks the special luminosity and sparkle of a transparent watercolor, it is more substantial in its effect; its matte and slightly textured surface often resembles that of an oil sketch and the entire surface is usually covered with paint. The paintings in this book reveal that Chagall sometimes applies transparent and opaque watercolor in the same picture, and also draws in certain contours with India ink.

Gouache was occasionally used instead of tempera in medieval manuscript illustrations, and in the sixteenth and eighteenth centuries, it was used for miniature painting. In the last century, gouache was most often applied for special effects in transparent watercolors. Among modern artists, however, Chagall is not alone in his use of gouache. Some of the *Ecole de Paris painters*—for example, Bazaine, Dubuffet, Poliakoff, and Picasso—prefer it to watercolor. Matisse often used gouache. It is the medium that suits very imaginative, fast-working artists who like to experiment constantly and to change their ideas rapidly. These artists need a medium that responds quickly and can combine some of the advantages of oil paint with those of transparent watercolor.

The earliest watercolor by Chagall known to us is *The Musicians* (1907), which was painted when he was still a student at Yehuda Pen's academy in Vitebsk. His earliest works in gouache, such as *The Village Store, The Soldier,* and *Nude with Raised Arms,* date from 1910 and 1911. His series of prints—such as the etchings for the fables of La Fontaine—are based on gouache sketches and ". . . in the process of transposing the color effects of the original gouaches," Venturi writes, "into the new medium, blacks and whites became subtler, more varied, more deeply felt." Chagall also employed the very versatile gouache medium for setting down his first ideas before embarking upon enterprises of enormous magnitude, such as his designs for the stained glass windows in Jerusalem, or the huge ceiling which now embellishes the Paris Opera.

Color Plates

Plate 1
FRUITSELLER
1909-10
Watercolor
7½" x 5½"
Collection Mr. and Mrs. Henry Sieger, New York

In this tiny painting, the size of a sheet of notepaper, executed in a sketchy, cursory manner and based on a two-dimensional flat design, a great deal of the paper is allowed to shine through. Note the interplay between "positive" and "negative" areas—those filled with color and those left in white. Also observe the use of "dots"—the leaves on the trees, the fruit in the baskets—as a unifying design element. The strict frontality is reminiscent of peasant paintings.

This is a very Russian picture. As one can also see in the work of Larionov, and even of young Kandinsky, Russian artists turned away from studio subjects to "go down to the people." In the early paintings of Chagall, peasant women with baskets, watercarriers, coachmen, soldiers, and similar types—not necessarily related to the ghetto of Vitebsk —appear frequently. At the beginning of the twentieth century the walls between Jews and non-Jews had begun to crumble and Chagall could freely watch the *muzhiks* at work. Even after he had become world famous and immensely rich, Chagall never forgot his own humble origin, and he feels at home with people who do manual labor.

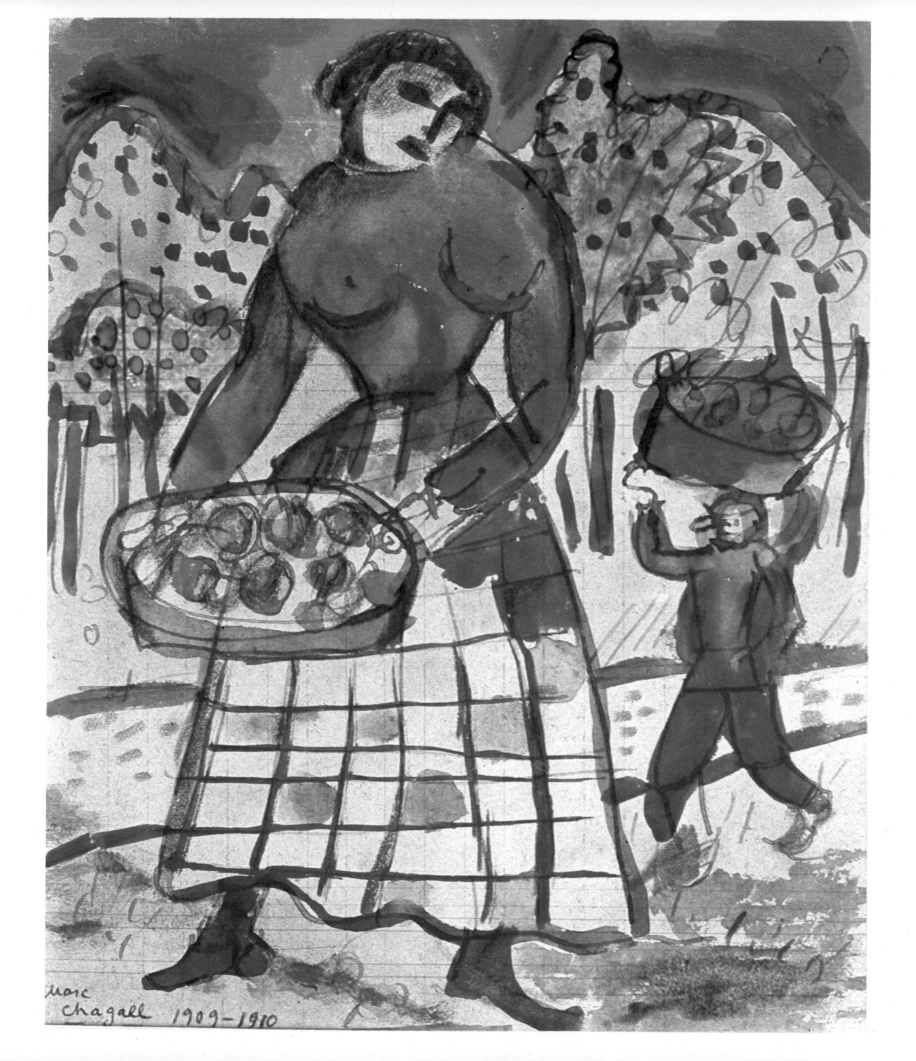

Marc
Chagall 1909-1910

Plate 2
TO MY BETROTHED
1911
Gouache
24" x 17½"
Philadelphia Museum of Art, Philadelphia, Pennsylvania

This picture is the study for a large oil, *Dedicated to my Fiancée* (Kunstmuseum, Berne, Switzerland). The gouache, like the oil—which differs from the sketch only in a few details—is one of the most puzzling and disquieting of the master's early works. A man, elbow resting on the table, wears the head of a bull; he gazes thoughtfully into the vortex before him. A woman has climbed on his back, her legs almost encircle him and she spits into her partner's "face."

The erotic implications of this "Beauty and the Beast" picture are undeniable. When the oil was submitted to the Salon des Indépendants, it was considered pornographic, because the lamp on the table looked like a phallic symbol. The painting was accepted only after the artist made a few small alterations.

Dedicated to my Fiancée was one of the first pictures Chagall painted in *La Ruche* (The Beehive), a building with many studios occupied mostly by impecunious young artists. By the light of a kerosene lamp he painted it in one night without interruption, lest the flow of creative inspiration ebb. Chagall called it "a sort of bacchanal, like those of Rubens, only more abstract." This title—like some others of Chagall's picture titles—was suggested by the poet, Blaise Cendrars; the artist accepted it unhesitatingly as appropriate.

The study, like the finished oil, is characterized by violent movement and nervous brushwork. It combines—as do most works produced by Chagall between 1910 and 1914—proto-Surrealist, as well as Expressionist features, and is exciting to the point of being disturbing.

In 1913, the oil, along with other works by Chagall, was featured at Herwarth Walden's historic First German Autumn Salon in Berlin.

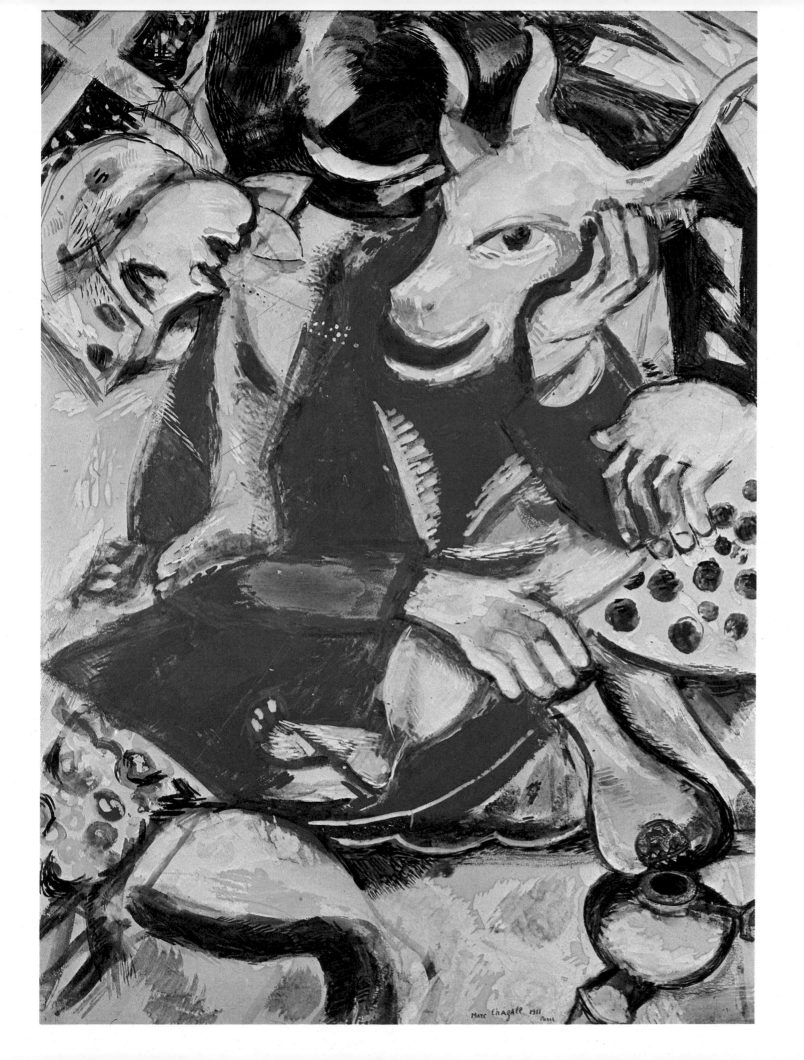

Plate 3
THE QUARREL
1911-12
Wash with pencil
11⅜″ x 9½″
The Solomon R. Guggenheim Museum, New York

The space in this picture is divided into four major areas. Viewed clockwise here are white, red, white, red, and they contribute a sense of movement to the design. The perspective is often rationally wrong but, for this very reason, it is highly effective. Among the paintings presented here, this topsy-turvy picture is the only one with clearly recognizable Cubist features. Chagall borrowed the geometrical division of space from Picasso and Braque. Like them, he was not concerned with the traditional device of fooling the eye into accepting the flat canvas as a substitute for corporeal reality. With the exception of one or two pictures, however, Chagall never aligned himself with the Cubist goals so closely as to conceal the figures and objects by near-illegibility.

There are other influences visible here. One seems to be the icons which Chagall admired in a museum at St. Petersburg. These pictures were characterized by the juxtaposition of strong, pure colors; by distortion of the figures, lending "Expressionist" vigor to these religious images; and by sharp outlines against a solid color background. There are also links to the Russian Neo-Primitivists, Mikhael Larionov and associates, who loved to paint scenes taken from the life of the simple people. Finally, Chagall's friend Robert Lelaunay comes to mind; he was the founder of Orphism and his chief interest was pure, autonomous color. Nonetheless, a genuine Chagall emerges.

This painting is related to the oil *Burning House* (also in The Guggenheim Museum); a similar commotion exists in both pictures. In *The Quarrel,* a bedstead, a mattress, and a pillow have been thrown out of the house. The limp figure, hanging over the window sill, looks half dead. A man in flight is holding what looks like a flaming torch. Note the dramatic clouds in the yellow, brown, and red sky.

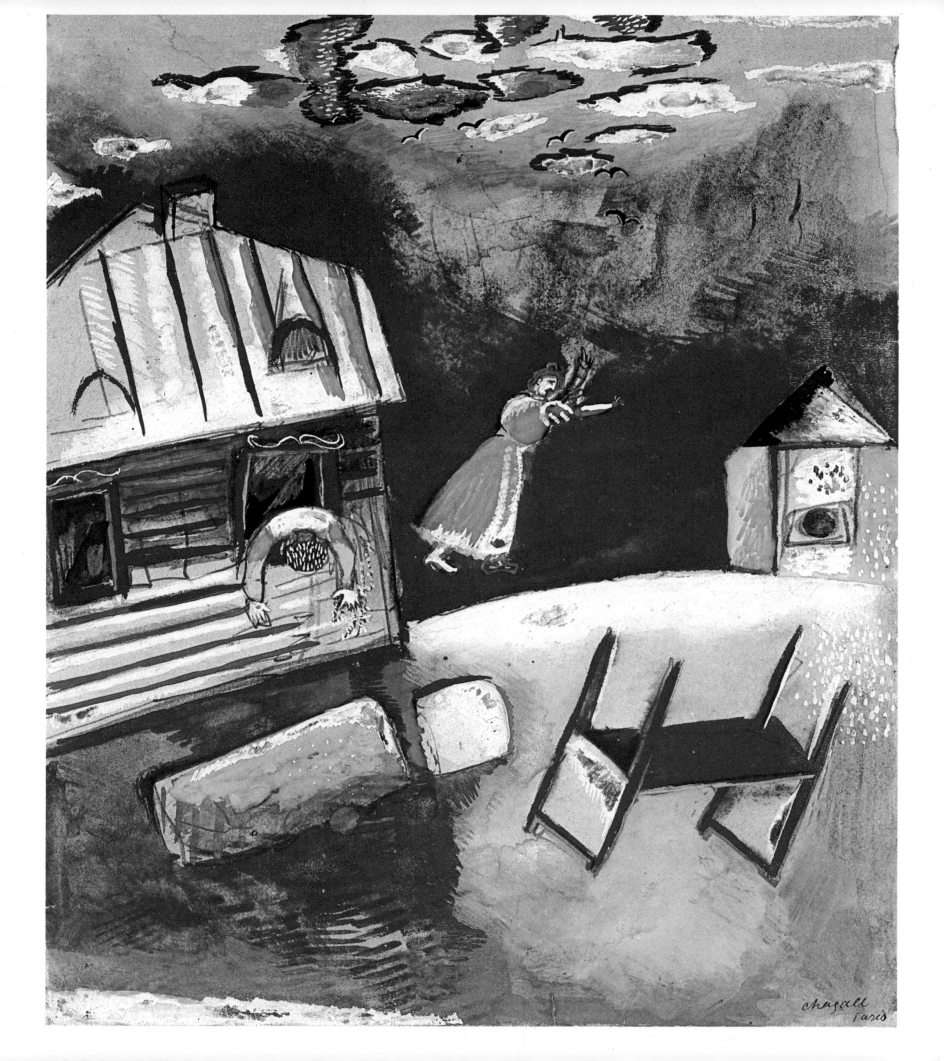

Plate 4
MAN AND WOMAN
1911-12
Gouache
12³⁄₁₆" x 9"
Worcester Art Museum (The Dial Collection), Worcester, Massachusetts

This is one of numerous works of art collected by Scofield Thayer who was the editor of *The Dial,* one of the foremost *avant-garde* periodicals of the twenties in the United States. The entire Dial Collection was loaned by the heirs of Mr. Thayer to the Worcester Art Museum.

The subject matter of *Man and Woman* is an unusual one for an East European Jew of Chagall's generation. Chagall grew up in a milieu in which nudity was frowned upon; Jewish men were not even permitted to look at a woman washing clothes because her arms were exposed. Males were not allowed to engage in free conversation with women, and promiscuity was rare. As Maurice Samuel put it in *The World of Sholom Aleichem,* "Jews were too busy having children to bother with sex." Young Chagall, however, was seemingly unhampered by taboos and restrictions; even before his arrival in Paris he drew and painted nudes with great abandon.

Yet the homage Chagall paid to the female body was not like that of Renoir and Bonnard. His generation looked neither for "charm" nor "beauty." Unlike those of the *Salon* painters, Chagall's nudes were not enveloped in the perfume of the boudoir, but continued the trend created by Courbet's pitiless realism. It was immaterial if woman's vanity suffered in the process. The modern nude is almost always "ugly." But with all her blemishes and imperfections, she can be more exciting than the impeccable nude—the type painted by academicians who deliberately sought a physical form devoid of any blemish. The traditional "nude" conformed to a preconceived ideal that divested it of humanity. Nothing was further from the intention of young Chagall than the glorification or idealization of woman.

The naked female body, as Chagall interprets it here, is an instrument for lust, yet it is not an attractive figure. Note the strange angularities. The faces of both the man and woman—the man exists here only in a marginal way—are made to look blunt. Nevertheless the untamed impetuous force of raw eroticism is well expressed. The strands of pearls and the earrings suggest that the woman is a prostitute. Note the crude *bidet* in the foreground, the samovar in the upper left corner, and the poodle beneath the bed. No shadows are cast by the objects or figures in the painting. Its design is characterized by a combination of horizontal and vertical lines which contribute to a stark "naked" feeling in keeping with the subject matter.

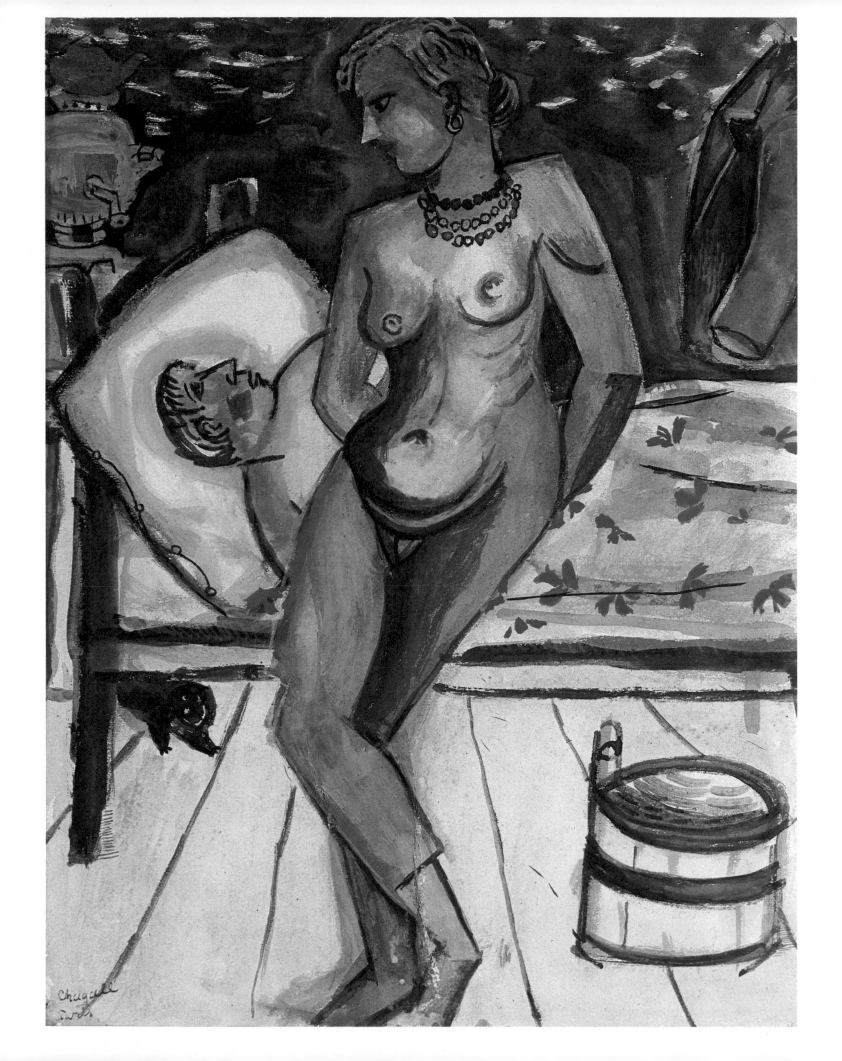

Plate 5
WATERCARRIER UNDER THE MOON
1911
Ink and gouache
9⁷⁄₁₆″ x 12³⁄₁₆″
Worcester Art Museum (The Dial Collection), Worcester, Massachusetts

In the rural sections of Eastern Europe fresh drinking water was drawn from wells or cisterns by professional watercarriers. They peddled water through the villages since there was no central supply.

Although this picture has a sketch-like quality, the figures are placed in a calculated and clever way. The central character is the watercarrier. The young couple on the right, embracing under a tree near one of the houses, is echoed by the boy practicing handstands on the left. The two people on top—the woman coming home with a market basket, and the grandfather hobbling along, aided by his stick—are moving in opposite directions. This symmetry is even true of the objects; one bucket is balanced by the other, one house by the second house. The curve of the top of the hill corresponds to the shape of the watercarrier's yoke.

The season appears to be late spring, for the flowers are in bloom and there is a feeling of gaiety in the air. It is a pleasant evening, lit up by the large sickle of the moon. Although the treatment of this painting is very light and perfunctory—the pigments were applied on wet ground!—it communicates completely the atmosphere of rural life.

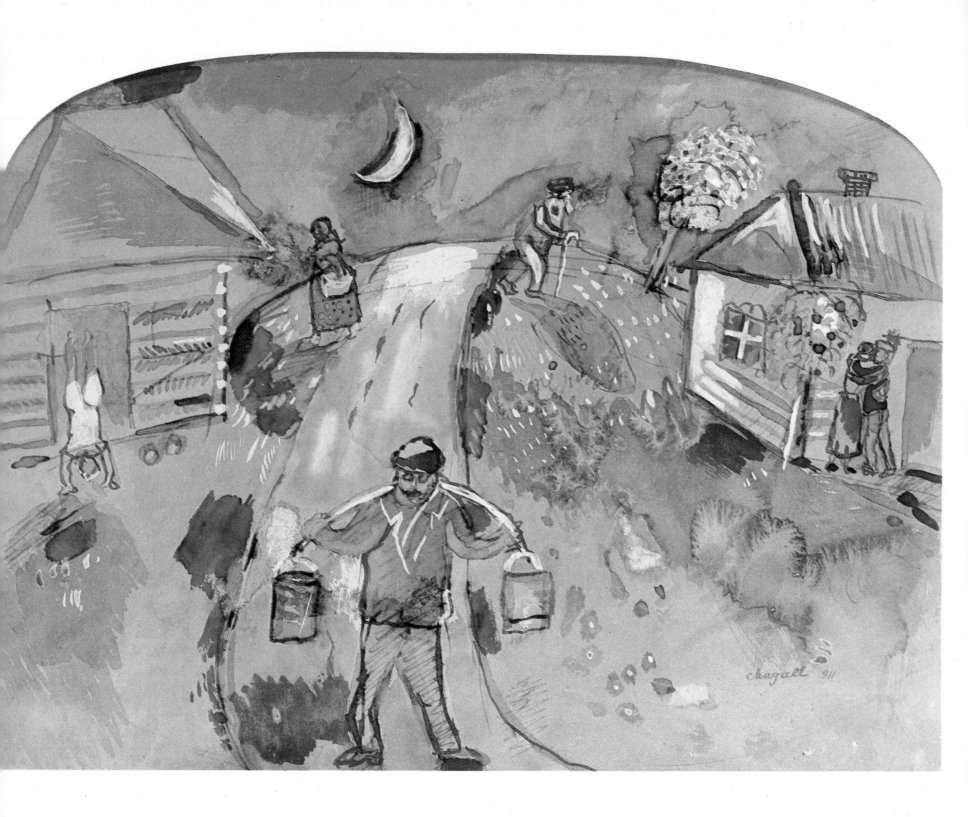

Plate 6
ABRAHAM'S SACRIFICE
1912
Gouache
7¼" x 6½"
La Boetie, Inc., New York

This small picture, as the Russian inscription at the top confirms, refers to one of the most important incidents in the Old Testament. God commanded Abraham to take his only son, Isaac, to the land of Moriah to "offer him there for a burnt offering upon one of the mountains which I will tell thee of." However, as Abraham was about to kill his son an angel of the Lord stopped him—"For now I know that thou fearest God, seeing thou hast not withheld thy son, thine only son, from me." So, instead of sacrificing the boy, Abraham made a burnt offering of a ram that had been caught by his horns in a nearby thicket.

The episode, from the twenty-second chapter of Genesis, has long been popular with artists. Among the most celebrated sculptures on the subject are a group on the middle portal in the north transept of Chartres cathedral (about 1230), and a marble group by Donatello and Nanni di Bartolo (1421) that originally graced the Campanile in Florence and is now in the Museo di S. Marco of the same city. On this theme, Rembrandt made a painting (1635), which is now in the Hermitage, Leningrad, as well as an etching (1655). Chagall completed a pen drawing to illustrate a poem on this subject by the Yiddish writer Abraham Walt. There is also an etching devoted to this theme among Chagall's Bible prints. There a bearded, hairy, thick-set Abraham is seen brandishing a knife in one hand, while the other hand holds his prostrate son firmly by the knee. A white angel, very bird-like, flies in from the left.

In this early, rather cartoon-like gouache, the story is depicted with all the primitive fervor of folk art. The angel has a very feminine quality. It is possible that the artist was thinking of his own guardian angel, his mother, who so often interceded on her son's behalf with his stern father.

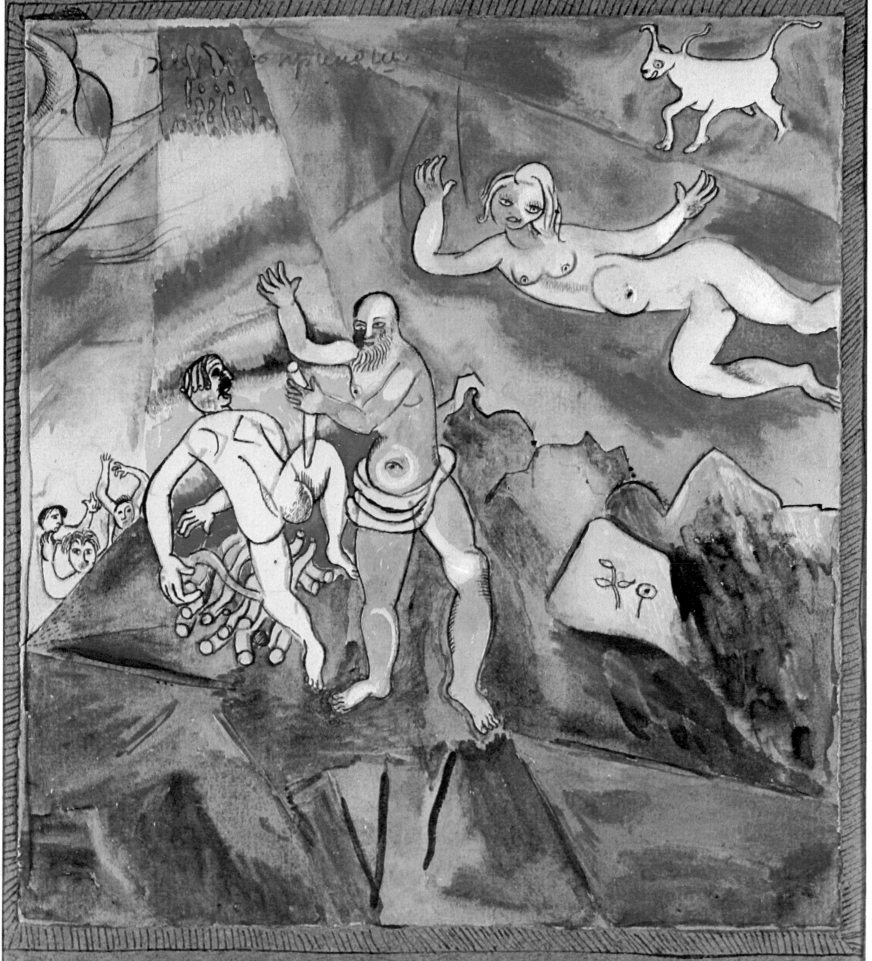

Plate 7
IT IS WRITTEN
1912
Gouache
11⅝₁₆″ x 8″
Worcester Art Museum (The Dial Collection), Worcester, Massachusetts

Both the French title, *On Dit* ("it is said"), and the English title, *It is Written,* define the subject of this sketch for an oil that is variously known as *The Pinch of Snuff, The Scribe,* or *The Rabbi* (Private Collection, Krefeld, Germany). Although Chagall was surrounded by many new and exciting sights in Paris, memories of his youth in Russia were deeply woven into the fabric of his artistic vision. Here, a pious, elderly Jew—possibly a rabbi—takes a pinch of snuff from a little box. On his head he wears a *yarmulke,* the traditional skull-cap which is the head-covering imperative for prayer and for reading religious books. He also has the earlocks and long, untrimmed beard in literal obedience to Leviticus 19: 27, "Ye shall not round the corners of your heads, neither shalt thou mar the corners of thy beard."

The old man is immersed in the Talmud (the painting at Krefeld, which otherwise closely follows this sketch, shows the Hebrew writing clearly on the open pages of the book). Since a distinction is made between the *written* law (the Torah) and the rabbinical commentaries that are identified as *oral* law, both titles of the sketch describe the subject. The scene is a house of study, a *Bet Midrash.* We are shown the long table, the curtain covering the Holy Ark to shield the sacred scrolls from any profanation, and the essential objects for daily religious worship which are part of the customary furnishings of such rooms. The six-pointed star—the *Magen David*—is often used to decorate ceremonial objects and in this case the letter *He* and the apostrophe, inscribed within the hexagram, represent the divine name. The coloring is restained; black, yellow, and green color areas dominate the picture. The blue is carried into the beard with touches of white here and there.

In 1922 the picture was reproduced as a frontispiece in *The Dial.* The editor of this periodical called it "the best picture Chagall has painted and…one of the most intriguing pictures I have ever seen by any artist."

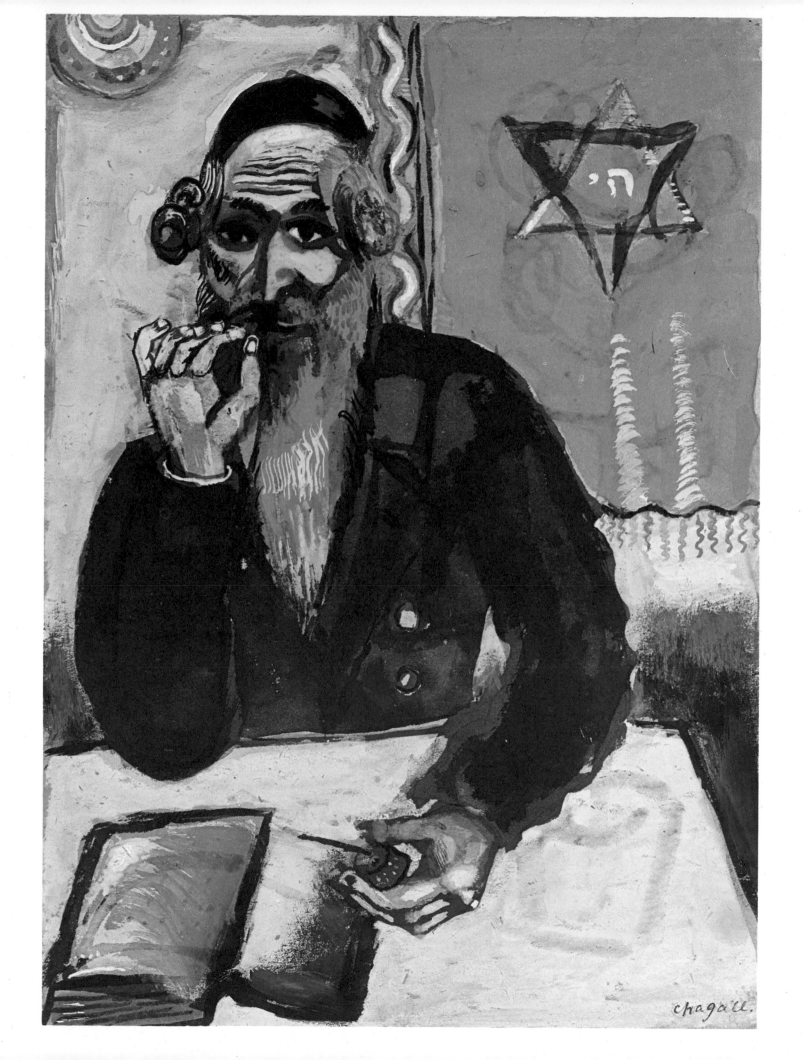

Plate 8
THE FAMILY DINNER
1923
Gouache
20⅛″ x 26″
Collection James J. Shapiro, New York

The young man carrying food on a napkin-covered plate recalls the central figure in an earlier painting, *Purim* (1916-18, Philadelphia Museum of Art). In both cases, the man wears a peaked cap, and is depicted walking in the direction of a wooden house at the left margin of the picture. The small oil, *Purim,* and the present gouache are dominated by vast expanses of red, representing the ground.

The picture in the Philadelphia Museum of Art, however, illustrates a Jewish festival in which it is the custom to carry gifts of food from house to house. Here, instead, we have an outdoor lunch, with a mother feeding her two children. Perhaps the man is carrying the food from the table to the tavern (*vide* the Russian inscription) in order to eat there as well as drink. The plaid cap and patterned trousers are probably as arbitrary as Chagall's choice of color. It is not likely that Russian village folk wore such lively garb.

The picture is astutely designed; there is a clear division from left to right—going upward to the right—which is broken by the figure of the young man leaning forward at a sharp angle.

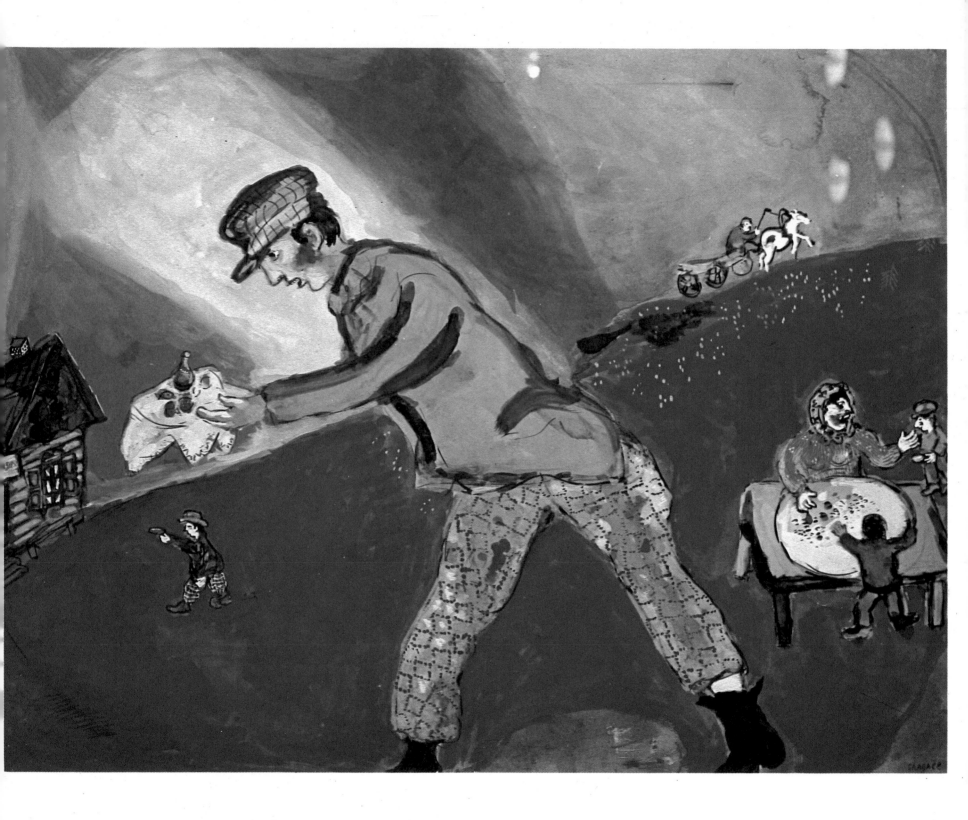

Plate 9
**MONKEY ACTING AS JUDGE OVER THE DISPUTE
BETWEEN WOLF AND FOX**
1925-27
Gouache
20″ x 16″
Perls Galleries, New York

The poet Jean de La Fontaine (1621-95) published many books, but of these only the *Fables* are still widely read. In France, every child knows these stories by heart. They have become a classic of world literature. The dealer, Ambroise Vollard, who had commissioned Chagall to make etchings for Gogol's novel *Dead Souls* in 1925, asked the artist to illustrate the *Fables*. The result was one hundred dazzling, heavily textured gouaches which were completed by 1927. When the translation of these gouaches into color etchings met with unexpected difficulties, Chagall finally agreed to substitute black and white etchings.

The news that a Russian Jew, rather than a native Frenchman, had been chosen to decorate France's most beloved literary treasure caused a storm of chauvinistic indignation. In his catalogue preface to an exhibition of the gouaches at the Bernheim-Jeune Gallery, Paris, Vollard defended his action: "If you ask me: 'Why Chagall?' my answer is, 'Simply because his aesthetic seems to me in a certain sense akin to La Fontaine's, at once sound and delicate, realistic and fantastic.'"

The animals that are the *dramatis personae* of this particular fable (the third in Book Two) were not to be found in the area in which the artist grew up (although there were wolves and foxes in the Russian forests). But Chagall is an animal lover, and he regards all dumb beasts with warmth and sympathy. The judge in this dispute is the ape who sits in the tree high above the complainant (the wolf, on the right) and the accused (the fox, in the foreground). In this gouache, Chagall did not attempt to illustrate the point of the fable; he only shows the characters.

In this he succeeded well, since he is in Vollard's words, "an artist of temperament . . . with a creative talent bursting with pictorial ideas."

The poem, as translated by Sir Edward Marsh (*La Fontaine's Fables,* Everyman's Library, London and New York), runs as follows:

A Wolf who had been robbed (unless he lied)
Summoned his neighbor in the wood—
A Fox, of record far from good.
Before the Ape the case was tried.
No barrister appeared on either side,
Each party making his own plea.
Never in simian memory
Had Themis been concerned with such a tangle—
His Honor on his bed of justice sweating,
Hour upon hour of noisy wrangle,
And the result still even betting!
Sizing them up impartially,
The Judge at last declared his line.
"My friends, I know you both of old," said he,
"And both of you may pay the fine:
You, Wolf, for swearing what Fox didn't do:
You, Fox, for taking what Wolf says you took."
Whate'er the facts, such was His Lordship's view,
One can't go wrong in jumping on a crook.

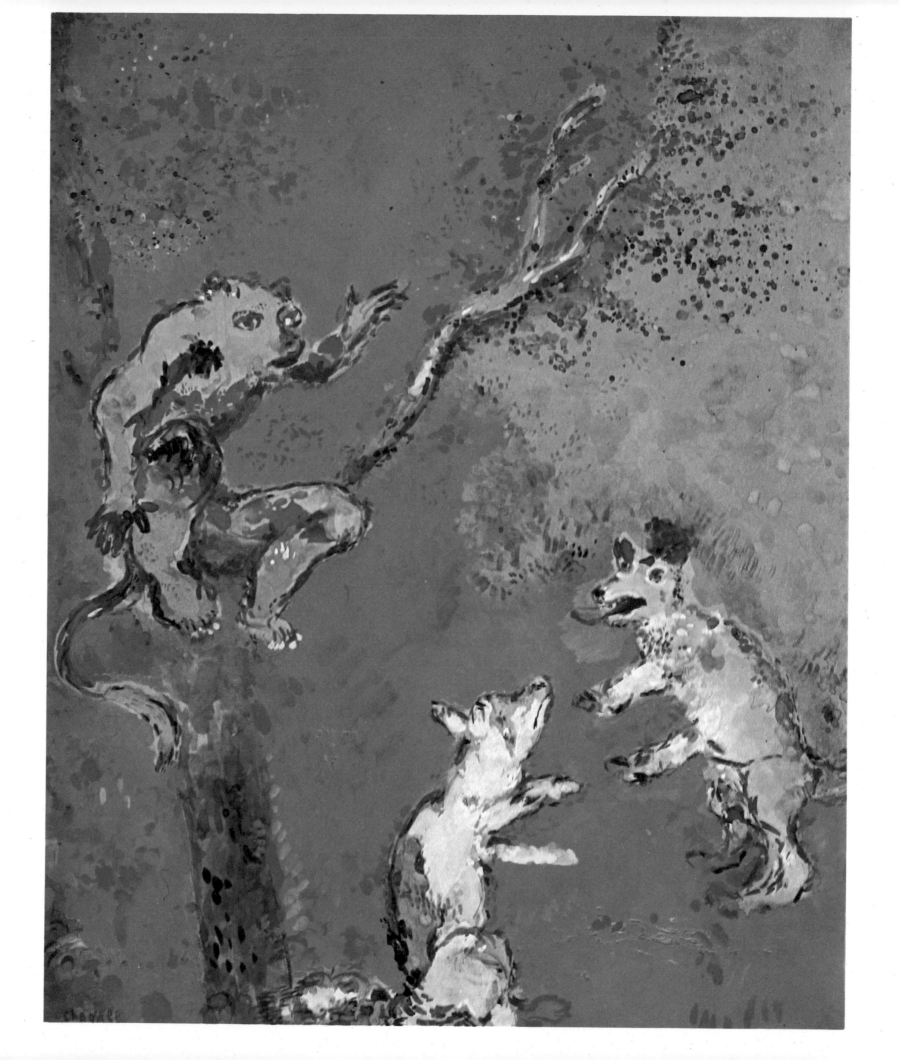

Plate 10
THE SATYR AND THE WAYFARER
1925-27
Gouache
19¾" x 16"
Los Angeles County Museum of Art, Los Angeles, California

In Greek mythology satyrs were roguish spirits, half man, half beast, that haunted the woods and mountains. In this gouache the male satyr is made to appear more virile by the strong red and green coloring which contrasts with the delicacy of the pink and yellow colors of the female. The wayfarer, a coarse, rustic figure, is seen blowing on his soup to cool it. The poem illustrated here is the seventh in Book Five of the *Fables*. In a rendering, also by Sir Edward Marsh, it runs thus:

In a mountain cavern rude
You could have observed a Satyr
Mustering his hairy brood
Round a savoury-steaming platter.

Squatted on the moss they were,
Father, Mother, and the mites,
Boasting neither rug nor chair—
Only splendid appetites.

When the meal was ready set,
Came an unexpected guest,
Driven in by cold and wet,
And was bidden to the feast.

It was needless to repeat
Such acceptable commands.
As the Traveller took his seat,
First he blew upon his hands.

Next upon the smoking broth
Daintily once more he blew.
"Friend," the astonished Satyr quoth,
"Tell me what it is you do."

"First I blow my fingers warm.
Then I blow my pottage cool."
And the Savage in alarm
Asked him, was he knave or fool?

"Either way, be off!" he said.
"Such a guest I fancy not.
God forfend that I should bed
One who blows both cold and hot!"

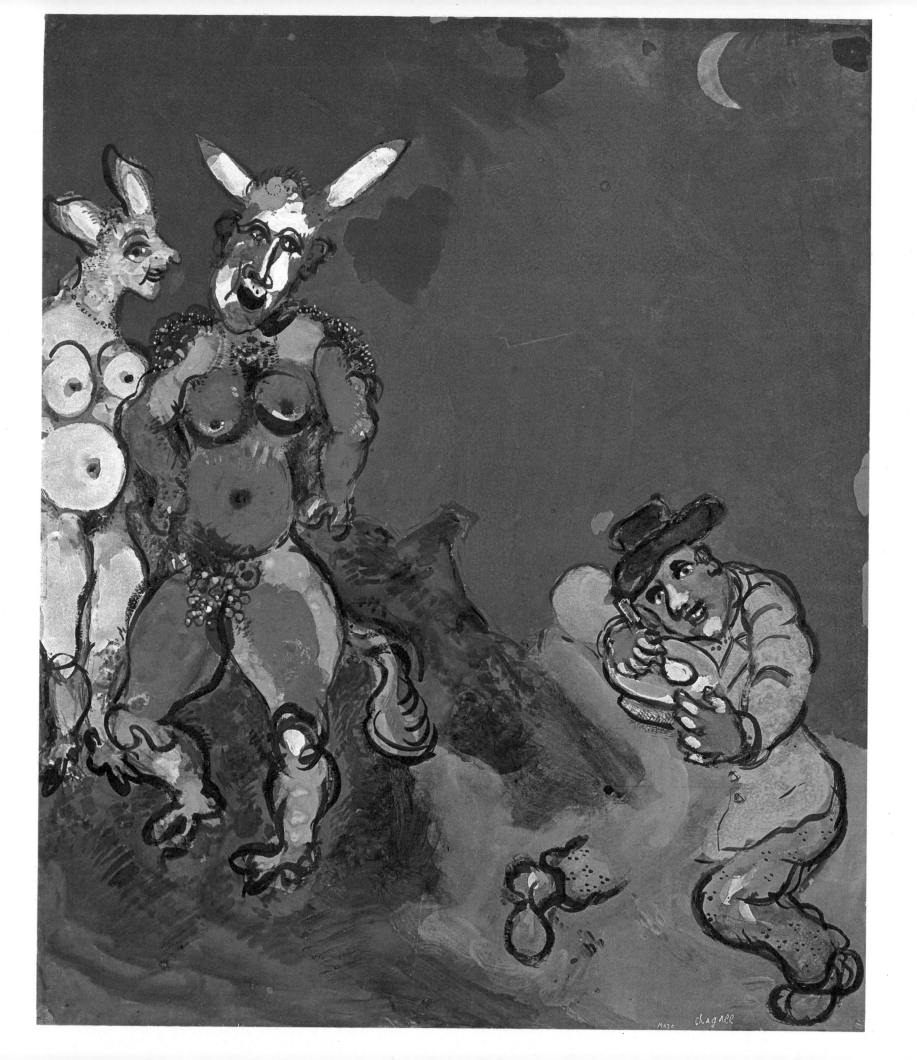

Plate 11
THE CLOWN MUSICIAN
1927
Gouache
24¾" x 19"
Collection Herbert H. Strauss, New York

The concept of the clown is believed to have been derived from representations of the devil in medieval miracle plays. It was further developed through the rustics who were portrayed on the stage, and through the fools and jesters (also called clowns) of the Elizabethan drama—"It is meat and drink to me to see a clown," runs a line in Shakespeare's *As You Like It*. The whitened face and baggy costume characteristic of the clown in these plays link him to the Pierrot, and this type of figure later became an indispensable part of the modern circus.

Degas, Seurat, Rouault, Beckmann and Picasso have often painted circus folk. Chagall was fascinated by the world of entertainment and loved to spend his evenings at the Cirque d'Hiver in Paris as a guest of his dealer, Ambroise Vollard, who had a box there. He once remarked, "I have always looked upon clowns, acrobats, and actors as beings with a tragic humanity; for me, they are like the figures in certain religious pictures." He also said: "Who is not a clown, even without a hat? Many people make their own circus and so they have no need to go there." Competing with beggars, peddlers, rabbis, and village musicians, clowns appear repeatedly in Chagall's work. Chagall's clowns have, however, a quite different quality from those in the work of Georges Rouault; Rouault saw clowns as representing the ideal way of life, and even went so far as to lend them the features of his own face. This particular clown by Chagall is rather grim-faced and the predominantly dark blue and black colors of the painting give it a somber atmosphere. There is a certain awkward absurdity in the way the clown is trying to play a fiddle while holding an animal in his arms. We feel sympathy, not Rouault's admiration, for this figure.

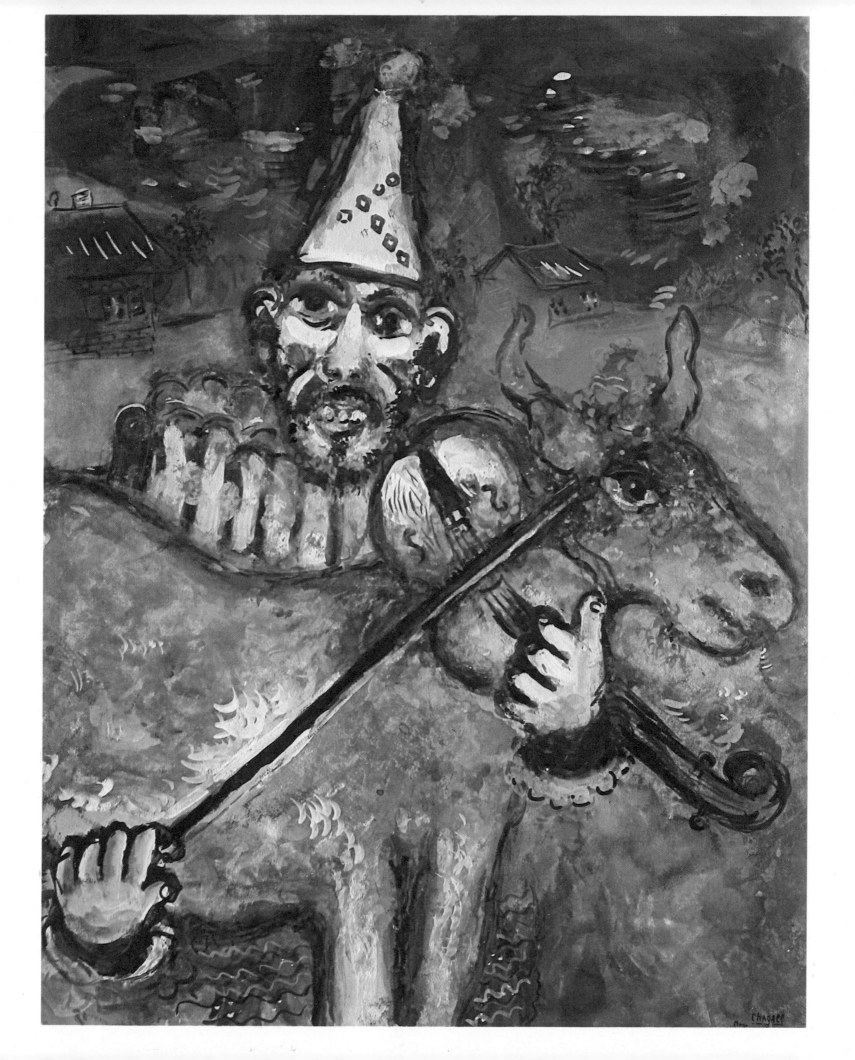

Plate 12
SNOW-COVERED CHURCH
1927-28
Gouache
23⅝" x 20⅛"
The Detroit Institute of Arts, Detroit, Michigan

In the French Alps during the winter of 1927 and 1928, Chagall, his wife and ten-year-old daughter experienced a landscape that was totally new to them. While staying in Chamonix, the principal town of Haute-Savoie, and in two nearby villages, they explored the area. The cold was as intense as the Russian winters, but this did not deter them. An oil and five gouaches were the fruits of this sojourn.

Although Chagall is best known for his "Surrealist" dream pictures which treat figures and objects in a rather free, non-naturalistic manner, there are other paintings in which he does not veer far from topographical reality. Such is true of this rendering of a simple Alpine church, surrounded by deep snow. The church is baroque in style—note the golden steeple, the small stained glass windows, and the carved figures of saints in niches above and to each side of the heavy portal. Beside the barren windswept tree a skier, exceptional in Chagall's work, is visible. The landscape of Savoie must have reminded Chagall of his native land for even the bulbous steeple resembles the Russian "onion" tower. The snow motif is reminiscent of many pictures of Vitebsk which show the inhabitants, wooden houses, and stone churches barely visible under a blanket of heavy snow.

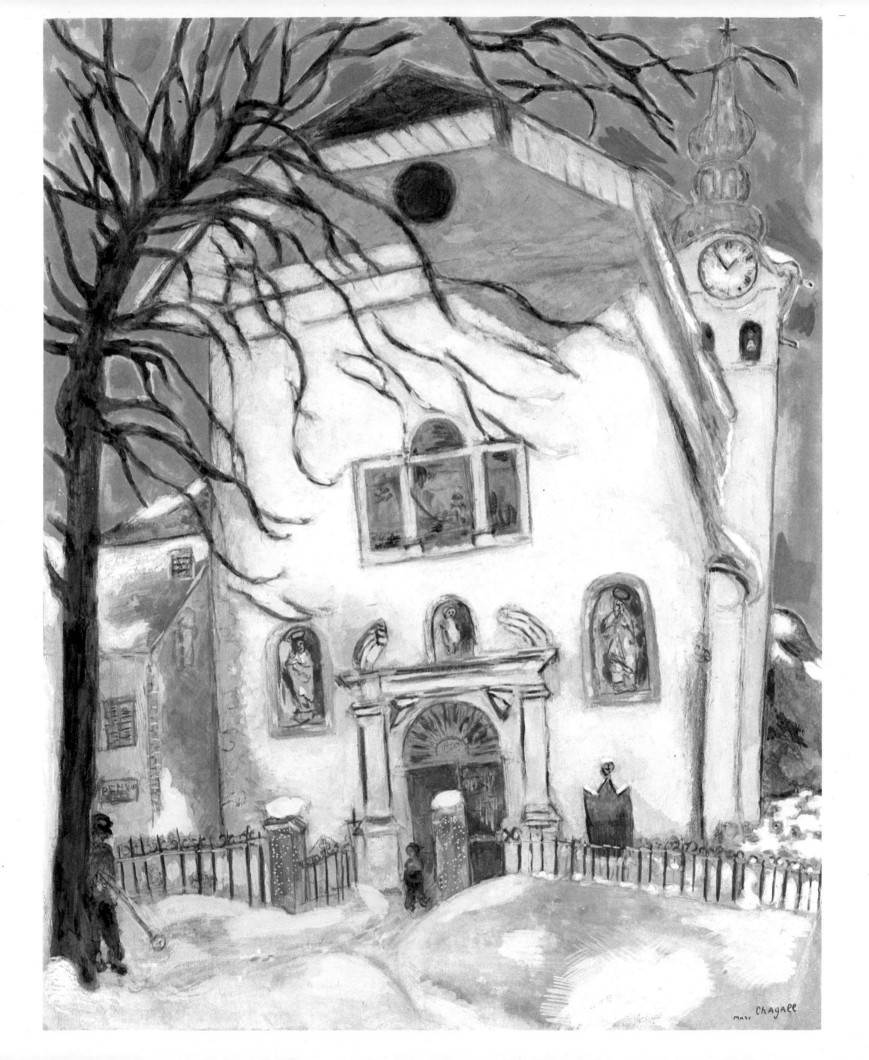

Plate 13
DANCER WITH A FAN
1928
Gouache
12½" x 19½"
Perls Galleries, New York

This picture was painted many years before the artist became actively involved with the ballet through his work on the sets and costumes for *Aleko* and *Firebird* in the early forties. Chagall has always been strongly drawn to the world of dance, and, according to his autobiography, when he was a teenager he flirted with the idea of becoming a dancer himself. Among his friends was Waslaw Nijinsky. *The Ballets Russes* of the artist's native country had been a great attraction for the entire Western world for many years. This particular picture might have been inspired by an entertainer the artist saw in a Parisian nightclub in the "flaming" twenties.

Note the strong contrast of the white in the dress against the dark blue of the background, and of the flat design of the triangular fan against the curves of the body. The only bright color note is supplied by the flowered border of the dress.

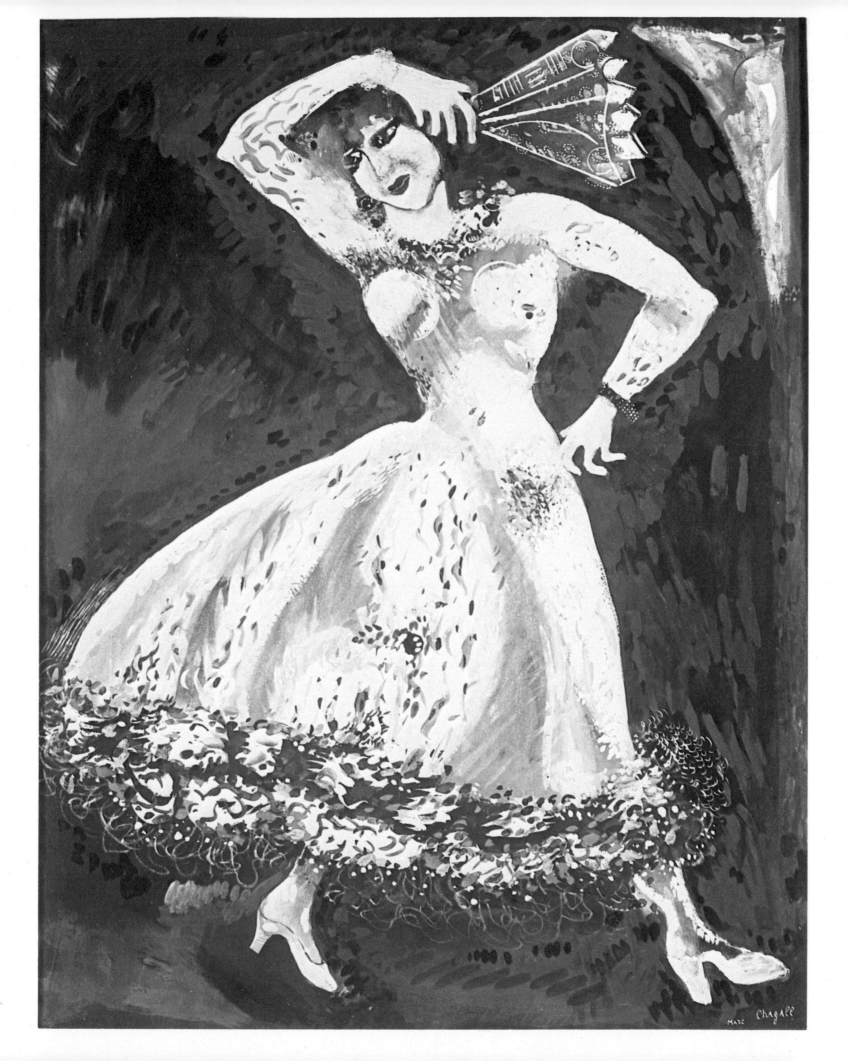

Plate 14
THE MIRROR
Ca. 1928
Watercolor
10½" x 8"
Los Angeles County Museum of Art, Los Angeles, California

The theme of a naked woman looking into the mirror appears quite frequently in the annals of art. The most famous picture in this category is perhaps the *Rokeby Venus* by Velasquez (The National Gallery of Art, London). Here in Chagall's watercolor an extra motif has been added. This motif of the sleeping lover may have been borrowed from Greek sources. The lover in this painting has a wreath around his head; is he supposed to be a poet, or a faun? Note the reflection of the eye in the mirror; it is much stronger than the eye in the actual face.

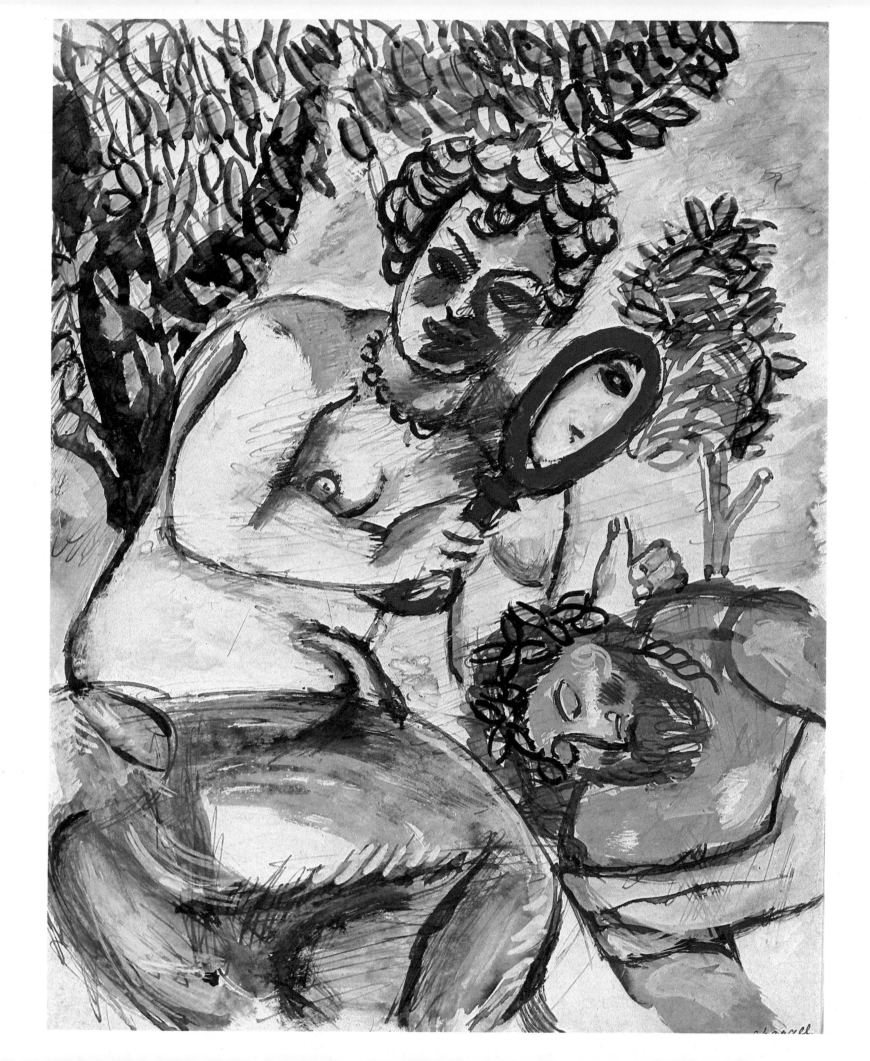

Plate 15
WOMAN AND HAYSTACK
Ca. 1930
Gouache and watercolor
25½" x 19½"
Albright-Knox Art Gallery, Buffalo, New York

A number of bucolic pictures very much like this one were painted by Millet and later by the Impressionists. This delicate little painting pleasantly conveys the mood of a hot summer day. The tired young woman rests wearily against the haystack, opening her pink thighs to the breeze. Her overly long arm, circling behind her head, seems to have no bones in it and conveys a sense of her relaxation. Note the hot red ball of the sun. Although the artist painted this picture in a combination of gouache and watercolor, it has a definite pastel quality.

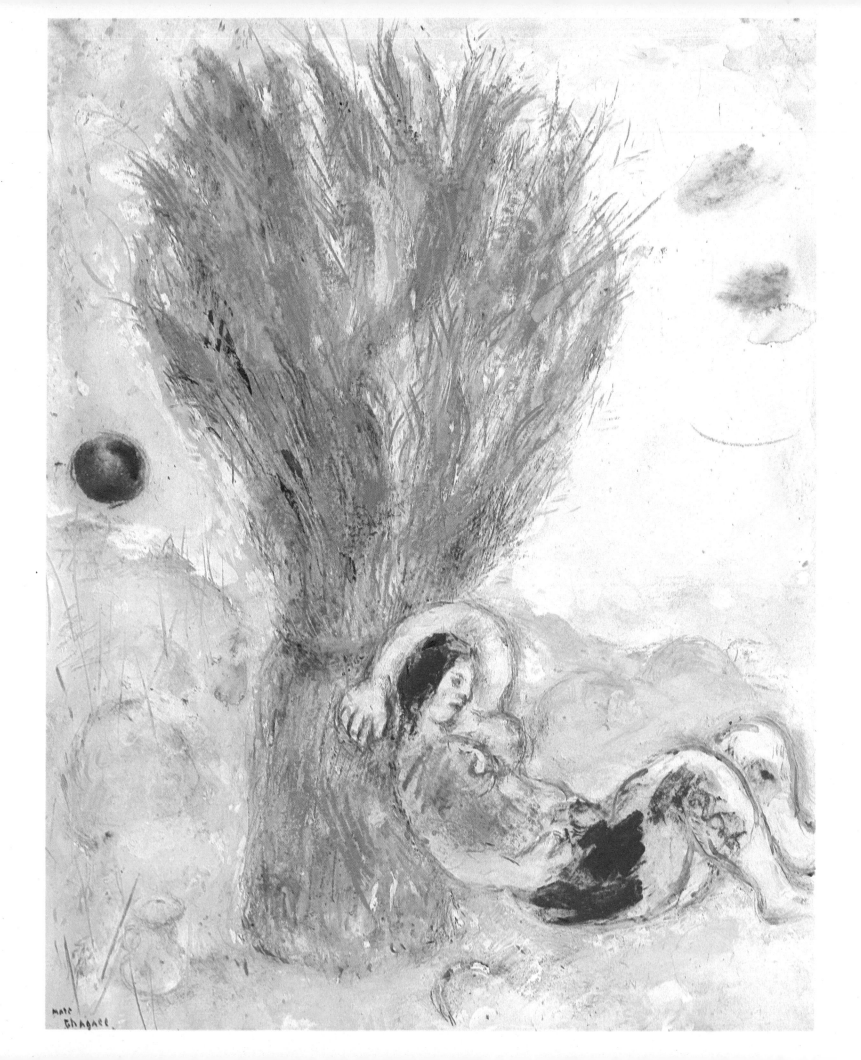

Plate 16
REVERIE
1931
Gouache
19⅛″ x 25⅜″
Perls Galleries, New York

Reverie is a state of being lost in thought or engaged in musing. Here we see a mauve-bodied nude reclining on a blue chaise-longue, lost in her dreams. The tilted head gives her an extremely pensive quality. She is surrounded by an icy Alpine landscape, complete with mountain village and fir trees. The landscape is probably one Chagall visited during his frequent vacations in the French Alps. The woman's face is stylized in a Surrealistic manner, and the solid forms of her torso merge into the fluid mass of her skirt in a way that makes her look like a mermaid.

Is the shape in the upper right corner supposed to be a polar bear?

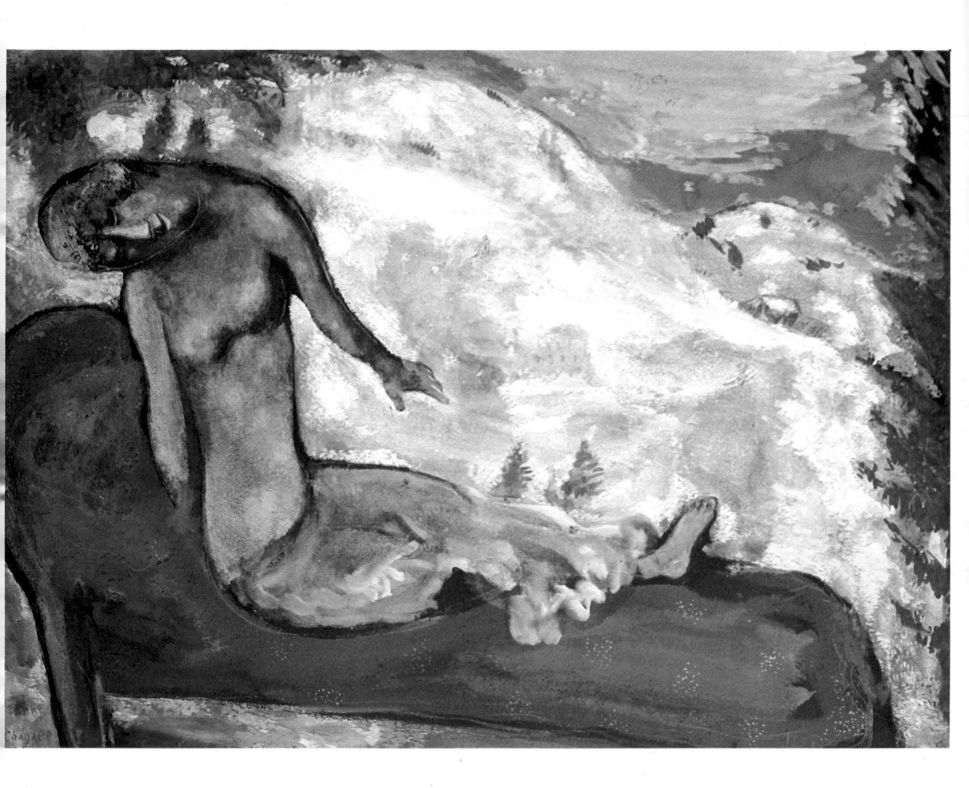

Plate 17
THE LOVERS IN THE MOONLIGHT
1938
Gouache
25¾″ x 19⅝″
Stephen Hahn Gallery, New York

This picture is also known as *Le Péché au Clair de Lune (The Sin in the Moonlight)*. In this very romantic scene, Chagall uses a palette which is as soft and subtle as that of Marie Laurencin. The two young people with their china doll faces are held together by a swooning passion. The man clasps his beloved in a firm grip which is both strong and tender. The lovers have substance and solidity. They are governed by the law of gravity and do not float weightlessly like so many of Chagall's figures. The background of the sky is painted in a Chagallesque blue, encircling the two completely. The color has a sensitive, lyrical quality which contributes to the mood of the painting. Despite all stylizations this picture communicates an extremely personal feeling.

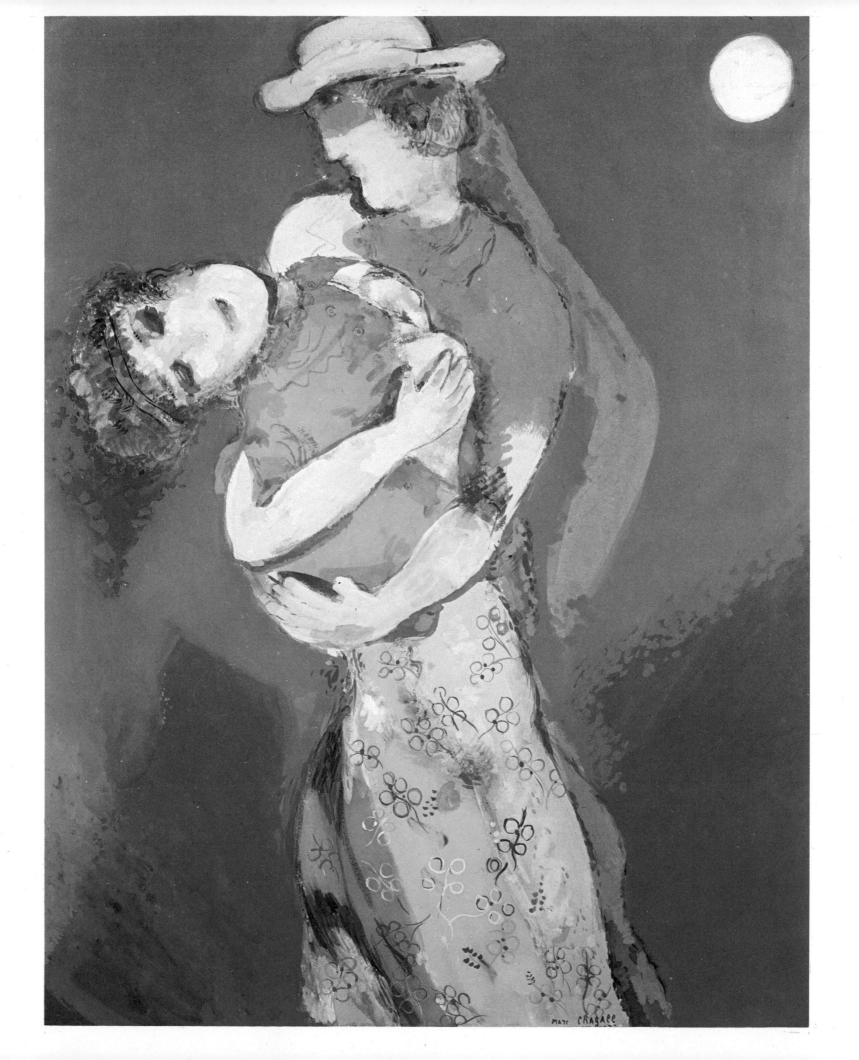

Plate 18
SNOWING
Gouache
26½″ x 20¼″
City Art Museum of St. Louis, St. Louis, Missouri

The theme of this picture recalls some of Chagall's much earlier works, such as *The Violinist* (1912-13, The Stedelijk Museum, Amsterdam) and *The Green Violinist* (1918, The Solomon R. Guggenheim Museum, New York). Chagall's Uncle Neuch played the violin "like a cobbler," and the artist himself, as a boy, took a few violin lessons. The fiddle was the favorite instrument in the Russian ghetto.

Although this picture offers the usual small town Russian winter scene, a clown instead of a *klezmer* (Jewish folk-musician) unexpectedly emerges in the center of the snow-covered road and his figure towers over the nearby church steeples. Above him there is an angel who has a blue donkey's head. There is a feeling of silence and loneliness about the scene, but one can almost hear the fiddler scraping away on his instrument. In the year when Chagall painted this picture (1939), he was mainly in the sunny south of France, so it is amazing that here he was able to succeed so well in recapturing the atmosphere of northernmost Europe in a deep winter's night.

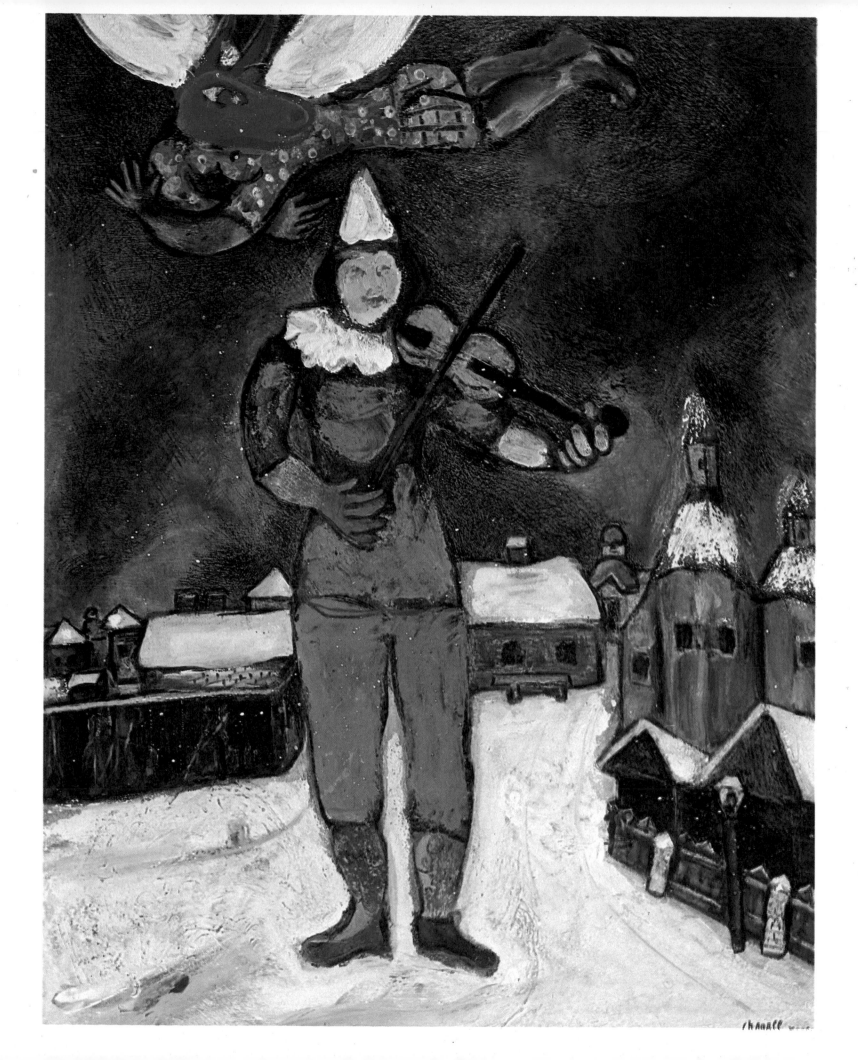

Plate 19
THE DREAM
1939
Gouache and pastel
20" x 26"
The Phillips Collection, Washington, D.C.

A dream is often the subject of paintings. Probably the most famous of these in twentieth-century art is Henri Rousseau's *Dream* (Museum of Modern Art, New York). Creative people, and artists especially, frequently have the most fantastic visions, awake or asleep. The Swiss poet and philosopher Henri Frédéric Amiel wrote: "Dreams are excursions to the limbo of things, a semi-deliverance from the human prison." Later, Freud, in his study of depth psychology, started to deal with the hallucinatory force of dreams, and with the strange motifs that arise from the subconscious mind.

In Chagall's work, the title "Dream" occurs frequently; in his autobiography, *My Life,* he told the story of a picture entitled *Apparition,* which was occasioned by a particular vision he had once had as a starving art student in St. Petersburg. Just as the most astute psychoanalyst will often be unable to "explain" fully the meaning of a complicated dream, so here the viewer can only guess at the theme in this overwhelmingly dark and somber, yet nonetheless not at all depressing work.

The scene represented is a Russian village at night, yet the couple sitting on the bed in the foreground are fully dressed. The angel—with wings like pillows rather than feathers—hovering above the couple makes one wonder whether this is a Jewish counterpart of the Annunciation scene. Is he rushing in to announce the good news of the woman's pregnancy? Above the door of the building in the lower right corner, three letters can be discerned; they could stand for Laz(arett), which means hospital. Is the rooster emerging from the building another announcer of good tidings?

The tiny building with a cupola in the upper right corner is also very mysterious because it does not look Russian at all. It could easily have been inspired by one of the photos and prints of Rachel's Tomb in Palestine, which were often circulated in Russian Jewish towns. The tomb stands beside the road from Jerusalem to Bethlehem; it is a shrine where barren Jewish women, to this day, go to pray for relief from their childlessness. (Rachel was quite old when she finally gave birth to Joseph and Benjamin.) During his Palestinian trip in 1931, Chagall had painted *Rachel's Tomb* (the oil is now in a private collection in Paris), and if the theme of this painting is, in fact, the Annunciation scene, the artist probably intended the tiny building to represent her shrine.

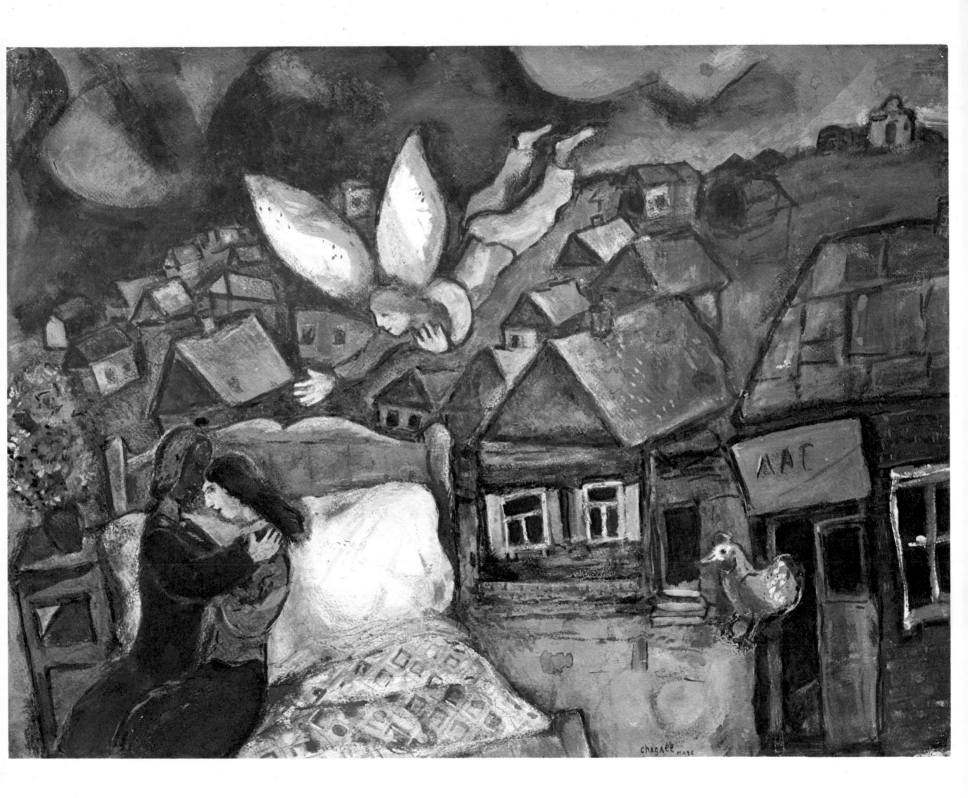

Plate 20
FRUITS AND FLOWERS
1939
India ink and watercolor
17½″ x 10¼″
Collection Victor Hammer, New York

This picture is so cheerful and gay, and entirely devoid of the blacks, dark blues, and somber browns so often mixed with the hot colors, that with it Chagall seems to have reached his apogee of Frenchness. The sensuousness of Renoir springs to mind, along with the *joie de vivre* of Matisse and the intense concentration of Cézanne. The painting is a product of Chagall's sojourn in southern France around the time of the outbreak of World War II. Political events were soon to displace him from the fragrant countryside and he was to find nothing comparable until his later visit to Mexico. About his own paintings of flowers, the artist has said: "I shall be satisfied if you recognize . . . that there lies in the flowers I paint, a subtle spell which makes them akin to the flowers of God."

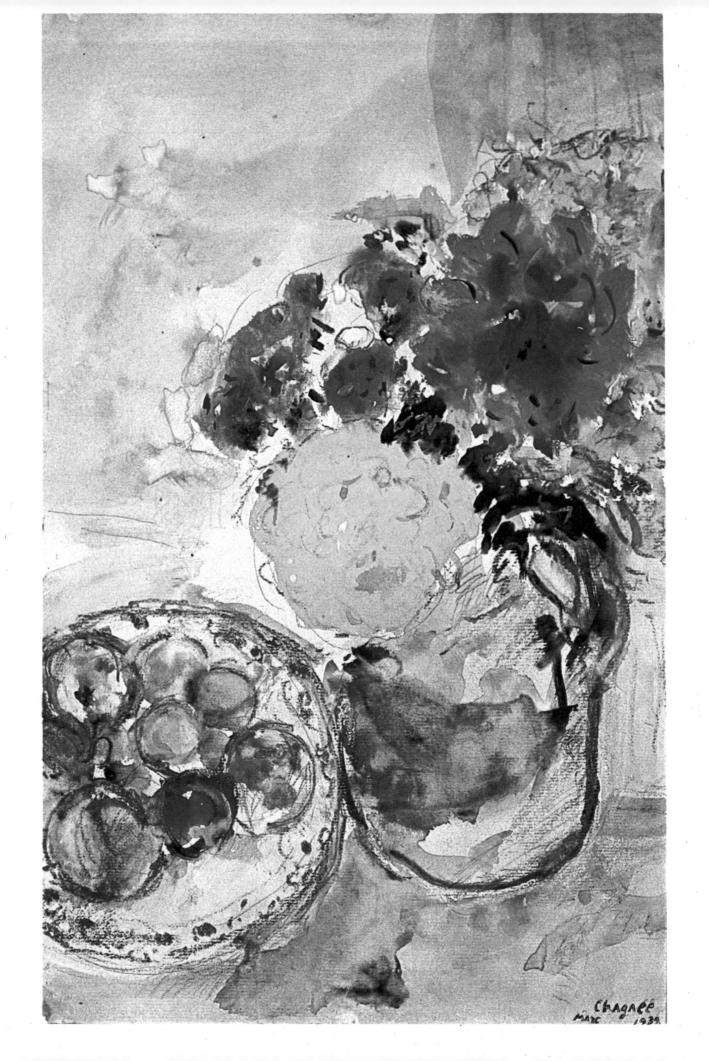

Plate 21
PERSECUTION
1941
Gouache
21¾″ x 14⅝″
Pierre Matisse Gallery, New York

It is surprising how often the most Jewish of modern painters has dealt with the most Christian of themes. Even before he came to Paris in 1910, Chagall made an ink drawing of the crucifixion. Since 1912 when he painted the famous *Golgotha* (Musuem of Modern Art, New York), there has been a stream of pictures presenting the tragic figures of Jesus on the Cross. However, to this artist Jesus was not the Son of God: "Christ is a poet, one of the greatest," he once wrote, "through the incredible irrational manner of taking pain onto himself." Jesus was a universal symbol through which Chagall could address himself to all of mankind—"For me, Jesus is a younger prophet among the pleiad of our great prophets."

In this picture Jesus is seen as the "Suffering Servant" foretold by the prophet Isaiah: "He is despised and rejected of men; a man of sorrows, and acquainted with grief." The gouache was painted soon after the artist's arrival in the United States in the summer of 1941. As a famous exile, he was well received and treated here, but he was unable to shake off the gloomy awareness that, because the Nazi forces had thrust into his native country, death and destruction now prevailed all over Russia. Chagall thus chose the crucifixion scene in order to protest man's inhumanity to man.

In this painting, Christ is shown hanging on the cross in a different manner from any of Chagall's earlier crucifixion pictures; his head is strongly tilted and his legs swing off the central beam. The traditional striped Jewish prayer shawl *(tallith)* is arbitrarily used as a loincloth. The background is a *stetl* (Jewish village) in Russia. An invader must have just left because several of the little wooden houses are aflame. A young woman and a child who were probably killed are shown lying toy-like on the ground. An alarmed mother is clutching her baby. People are fleeing. At the bottom of the cross a man in the peaked cap worn by rural Russian Jews is studying a book. This reference appears to be to the Jewish tradition of constant study and this figure seems to be the only element of calm and stability amid chaos and suffering.

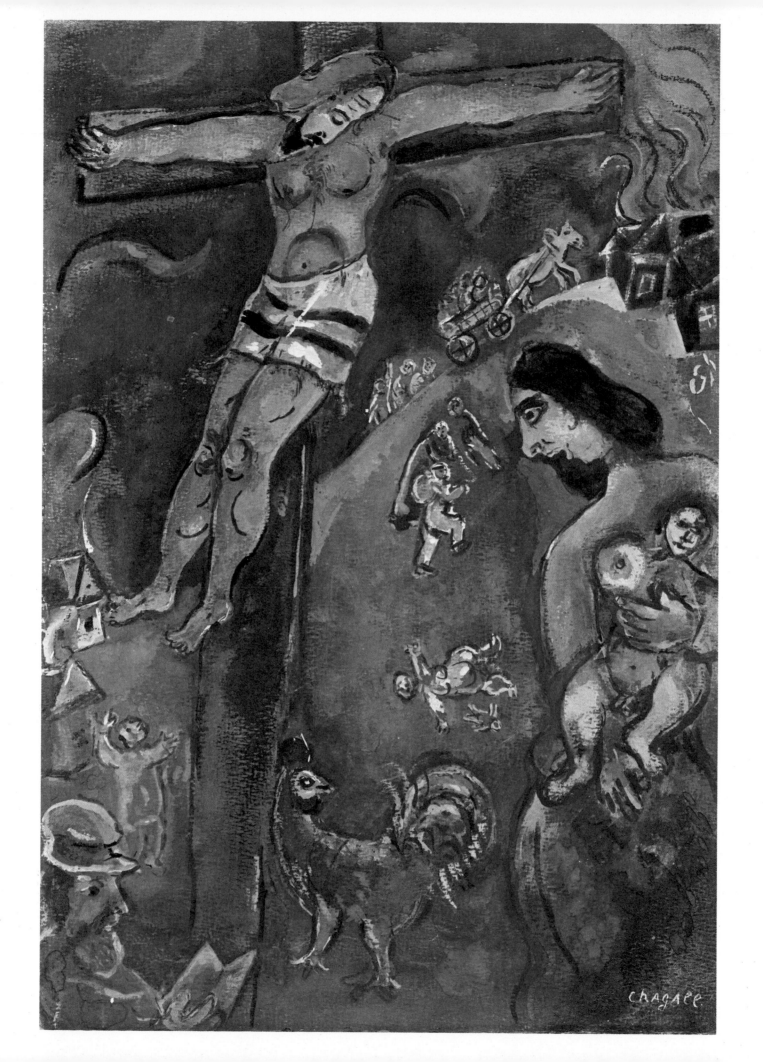

Plate 22
BASKET OF FRUIT
1942
Gouache
23⅜″ x 17⅞″
The Baltimore Museum of Art, Baltimore, Maryland

This picture was painted by Chagall in the summer of 1942, while he was staying in Mexico City to work on the sets for the ballet *Aleko*. His biographer, Franz Meyer, tells us that despite his preoccupation with this task, Chagall and his wife managed to take brief excursions outside the capital: "Chagall took advantage of them to do sketches that he used immediately after and also during the following year for his 'Mexican gouaches'. . . These works reveal his deep sympathy with Mexico and the Mexicans. He felt attracted by their ardent, generous nature and was pleased at their feeling for art and their response to his own work. It is these people that we see in the gouaches."

Mexico offered Chagall many startling sights and provided him with new themes. The women there carry objects on their heads with poise and grace. However, in this painting the two characters—the young female supporting her load slightly with an outstretched arm, and in the right background, the man in the sombrero strumming his guitar—are less important than the lush southern fruit, recorded with the same passion that Chagall applies to painting flowers. Everything is bathed in a celestial blue light that seems to come from nowhere; its source is certainly not the wisp of a moon in the picture's upper right corner.

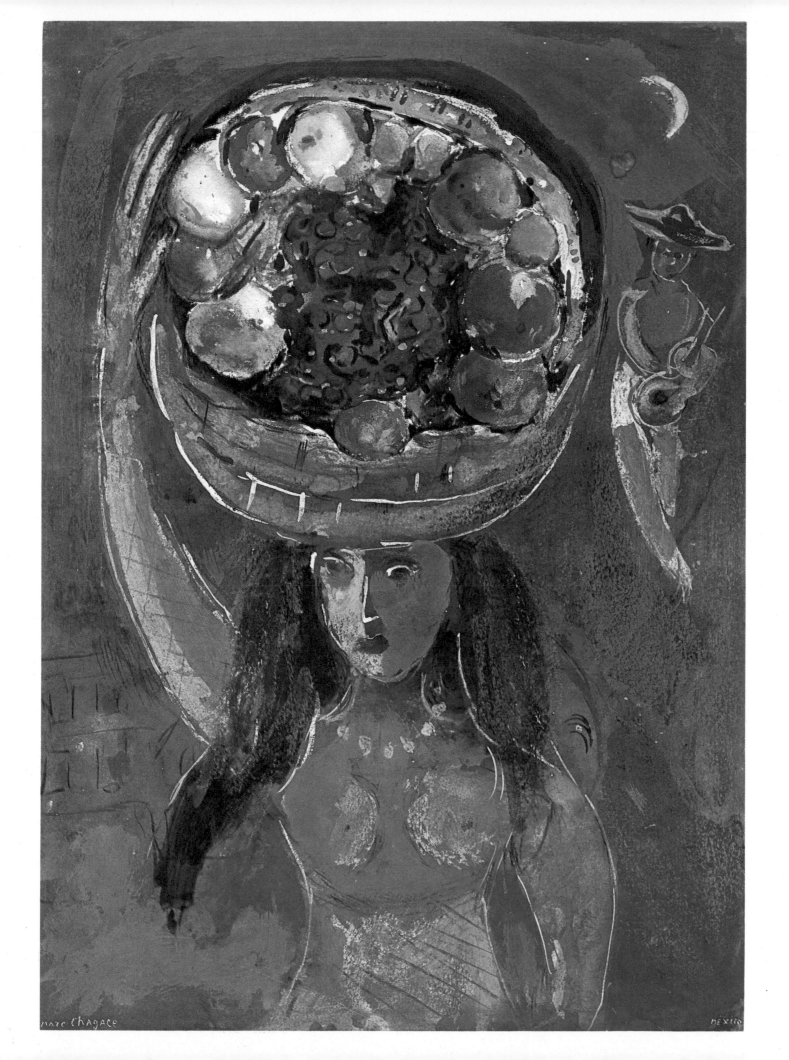

Marc Chagall MEXICO

Plate 23
ALEKO
Decor for Scene I: *Aleko and Zemphira by Moonlight*
1942
Gouache, wash, brush and pencil
15¹⁄₁₆″ x 22⁵⁄₁₆″
Museum of Modern Art, New York

As a refugee from Nazi oppression Chagall welcomed the commission by the Ballet Theatre in New York to design the decor and costumes for *Aleko* at the end of 1941. The music chosen for the ballet was Tchaikovsky's *Trio in A Minor for Piano, Violin and Cello,* as orchestrated by an American composer; the libretto was taken from Pushkin's long poem, *The Gypsies.* Aleko, a Russian youth, is bored with life and joins a band of gypsies. He falls in love with Zemphira, the daughter of their leader. But the fickle girl betrays him with a young gypsy. Aleko, mad with jealousy, kills them both. Thereupon he is banned from gypsy life.

This picture is a design for the backdrop of the first of the four scenes; Aleko and Zemphira are seen floating in the moonlight in a very Chagallesque fashion. The lover emerges from a mysteriously shaped cloud to stroke the hair of his sweetheart. The red rooster which appears in so many of Chagall's paintings floats through the sky. A round white moon lies in the middle of the swirling clouds.

The artist and his compatriot Léonide Massine, who choreographed the ballet, flung themselves with great eagerness into the project. In fact, Chagall and his wife went to Mexico City to work with Massine. After having made small sketches in gouache, Chagall painted all the huge sets with his own hands. Mrs. Chagall supervised the making of the costumes; in many cases, her husband had to touch them up to make the colors exactly right. The world premiere of the ballet took place at the Palacio de las Belles Artes of Mexico City on September 8, 1942. The enthusiastic crowd included the painters Diego Rivera and José Clemente Orozco. There were nineteen curtain calls. The first New York performance was at the Metropolitan Opera House on October 6 of the same year. On both occasions, the painter was called onto the stage again and again to receive the wild applause of the audience.

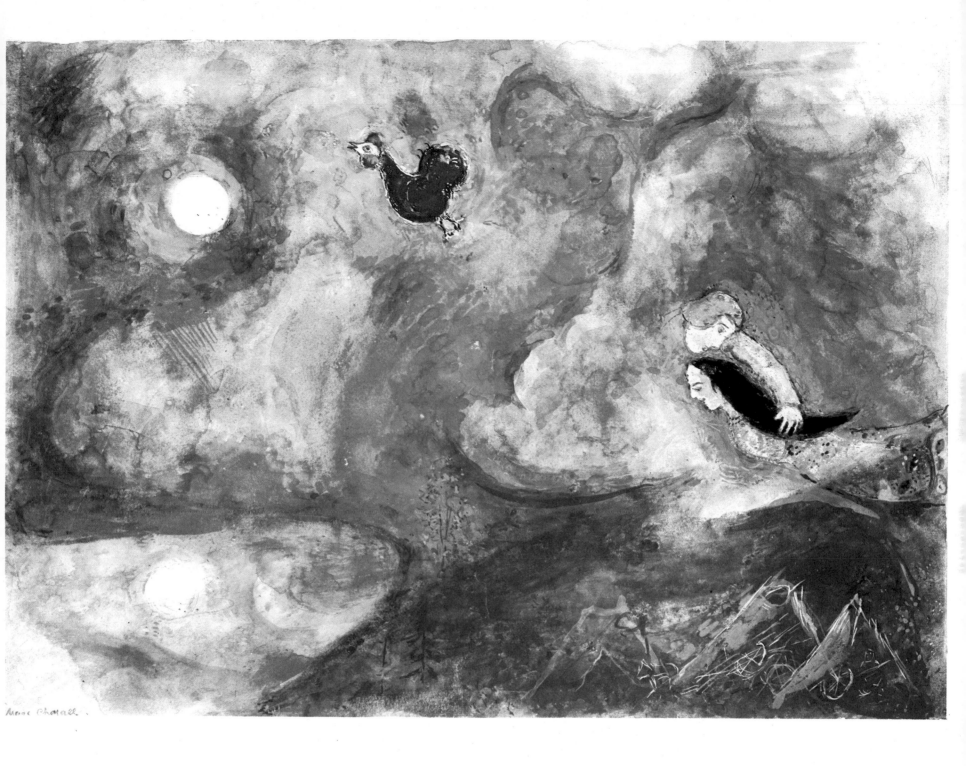

Plate 24
ALEKO
Costume for Scene I: *Zemphira*
1942
Gouache, watercolor, wash, brush and pencil
21″ x 14½″
Museum of Modern Art, New York

Working with Massine on the ballet *Aleko,* Chagall took particular pains to insure a perfect harmony between his large backdrops and the costumes he designed to be worn by the dancers. He insisted that these costumes be hand-painted, too, in order to become an integral part of the total scheme. (The idea of designing costumes as colorful complements to the sets had come from his teacher, Leon Bakst.) Nearly all of Chagall's original sketches have been preserved so that this particular production could be remounted. The Theatre Arts Collection of the Museum of Modern Art, New York, through the Lillie P. Bliss Bequest, acquired sixty-seven designs in mixed media for the ballet, including forty-eight designs for the costumes. In 1966 and 1967, a selection from them was first shown at the Museum of Modern Art, and then circulated throughout the United States. This particular sketch for Zemphira's costume is reproduced on the jacket of *Marc Chagall: Drawings and Watercolors for the Ballet* by Jacques Lassaigne (1969).

The costume was worn by the English ballerina Alice Markova who had made her debut with Diaghilev's ballet in 1925. She was chosen for the spirited role of Zemphira although she had become famous largely for more gentle, fragile, classical roles. She had been hailed as the greatest Giselle of her time in revivals of that early nineteenth-century ballet, and had achieved fame in several "white" ballets, such as *Les Sylphides* and *Swan Lake.* In *Aleko* she employed a rather free style of dancing, different from the delicate romanticism she had displayed in earlier parts.

Note the moon and red rooster which also appear on Plate 22.

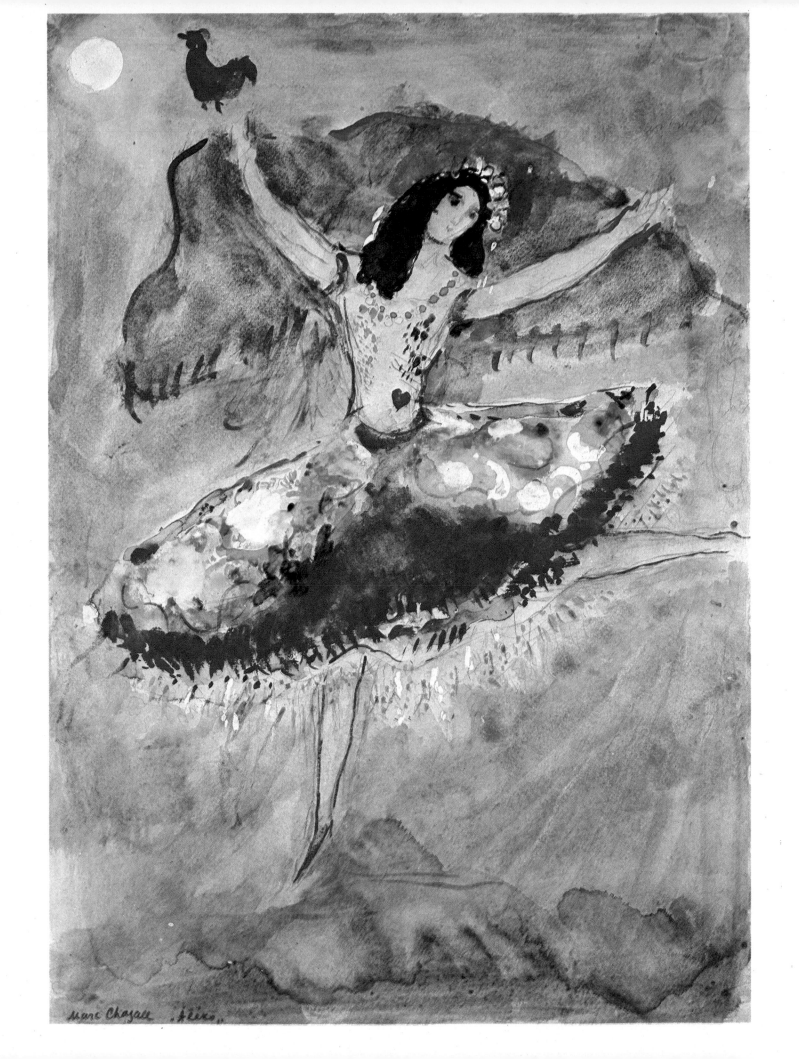

Marc Chagall "Aleko"

Plate 25
ALEKO
Decor for Scene III: *Wheatfield on a Summer's Afternoon*
Gouache, watercolor, wash, brush, and pencil
15¼" x 22½"
Museum of Modern Art, New York

This sketch for a stage flat has a very powerful effect, although the subject matter is very limited in scope. We see two immense suns, one directing its rays towards the vegetation below, the other consisting of ruddy circles, like a bull's eye. Below them a field of grain almost conceals a man wielding a large scythe and a man in a rowboat sails across a placid lake. Note the upside down tree that touches the lake's surface with its tip. The design is a far cry from the naturalistic stage decorations used by Stanislavsky and his successors.

Chagall had designed a set for a play at a Petrograd Theatre in 1918, which had been produced by a friend of the great director Meyerhold, of whom he was an enthusiastic follower. However, Chagall went further against tradition on that occasion by insisting that all the actors be made up with green faces and blue hands. When, around 1920, Chagall worked for theatres in Moscow, he proved himself again a true disciple of Meyerhold's "Style Theatre" which contrasted sharply with Stanislavsky's "True to Life" concept. Chagall did not envisage the theatre as a representation of a real world. For him, it was entirely a work of art. It should not deceive, nor attempt, in the guise of a play, to create the illusion of being reality. He believed the theatre to be a total work of art that would fulfill all poetic, didactic, and metaphorical functions of art.

Chagall's particular aims for the theatre were well outlined by Guenter Metken in a volume published in 1969, *Art and the Stage: Painters' and Sculptors' Work for the Theatre:* "He had visions of a poetic theatre free from all shackles, which would draw the spectator into the vortex of the imagery, cause him to lose himself completely in the fantastic events taking place on the stage. . . . By transmuting the banal into the marvelous, by giving the actors the character of marionettes . . . by stylized mime and grotesquerie, Chagall largely determined the whole of the production."

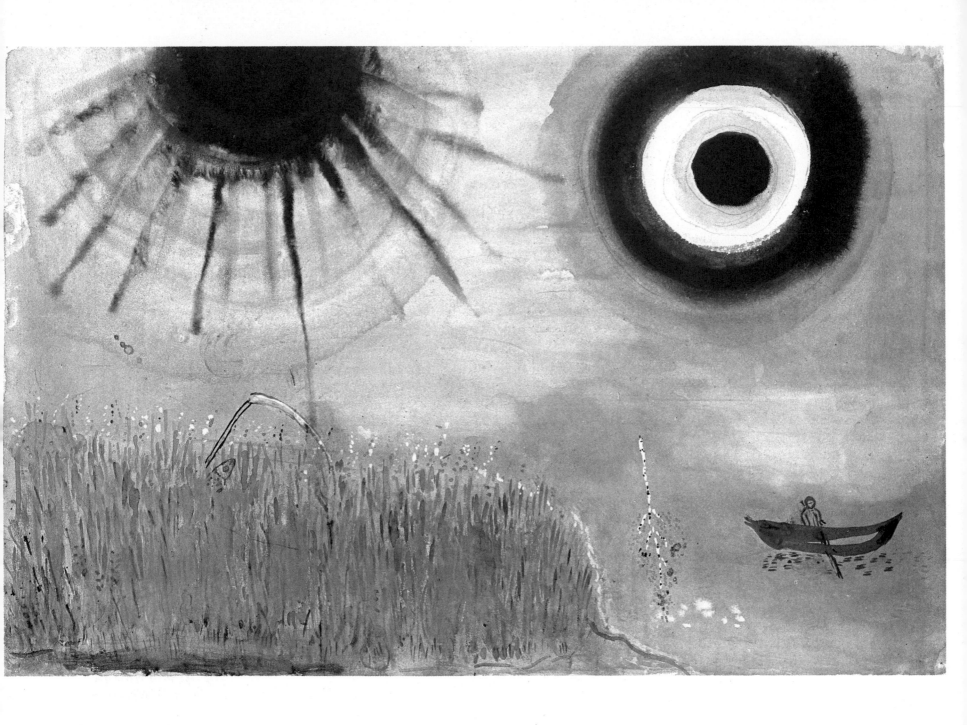

Plate 26
ALEKO
Decor for Scene IV: *A Fantasy of St. Petersburg*
1942
Gouache, watercolor, wash, brush, and pencil
15¹⁄₁₆″ x 22⁷⁄₁₆″
Museum of Modern Art, New York

"I wanted to penetrate into *The Firebird* and *Aleko* without illustrating them, without copying anything," Chagall once explained to his biographer Jacques Lassaigne. "I don't want to represent anything. I want the color to play and speak alone. There is no equivalence between the world in which we live, and the world we enter in this way" (he meant through the theatre).

Here the scene for the backdrop is indeed fantastic; it seems to be only loosely connected with the story. The prancing white horse in the center, the candelabrum above it, the strangely shaped clouds and the mysterious goat-like animals leaping through the sky to the right seem in themselves to be unrelated. Then there is the city of St. Petersburg in red beneath the horse (as "unreal" as El Greco's vision of Toledo) and, to the left, barely noticeable, the blue church with the cemetery and crosses behind. What does it all add up to?

It is conceivable that Chagall sees himself as too much of an individualist to subordinate any of his ideas to the requirements of the theatre. This would explain why his backdrops often look more like vast independent Chagall murals than integral parts of the production executed with the immediate need of actors, singers or dancers in mind. In fact, they often dwarf the performers by their visual force, as viewers of the Chagall sets for the performance of Mozart's *Magic Flute* at New York's Lincoln Center can confirm. At the same time Chagall, through his personal magic, admirably manages to create his own fairyland on the stage, with its spirit of eternal holiday. John Martin, dance critic of the *New York Times,* considered all of this when he wrote about the *Aleko* premiere in New York City: ". . . It is Chagall who emerges as the hero of the evening. He has designed and painted with his own hand four superb backdrops, which are not actually good stage settings at all, but are wonderful works of art. Their sequence is independently dramatic and builds to a stunning climax. So exciting are they in their own right that more than once one wishes all those people would quit getting in front of them."

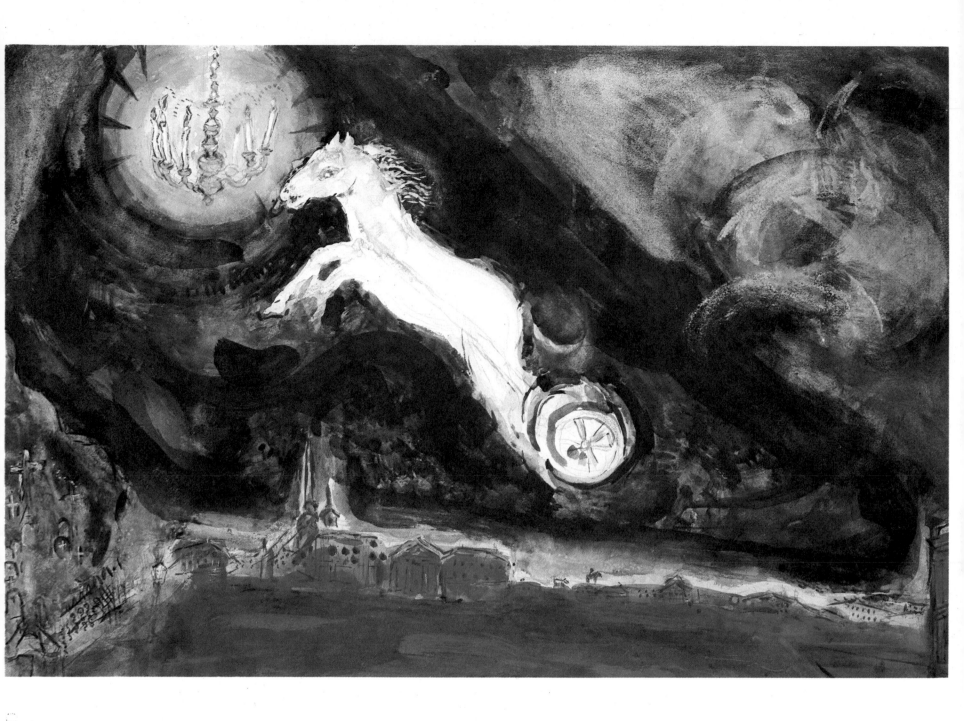

Plate 27
FANTASTIC HORSE CART
1949
Gouache and pastel
23¼″ x 18⅛″
Blanden Memorial Art Gallery, Fort Dodge, Iowa

It is one of the characteristics of Chagall's work that he happily weds the rational and normal to the irrational and abnormal; he presents absurd situations occurring in the most ordinary everyday surroundings. This type of village street, with its row of wooden houses (*izbas*), certainly must have been a common sight in Eastern Europe, at least up to the time of World War I. It is unlikely, however, that by 1949 when the gouache was painted, *izbas* were still in existence. After three decades of Communist reconstruction and after the devastations of World War II, some remnants of Old Russia may have survived, but such houses must have gone up in flames like tinderboxes. Thus Chagall probably reconstructed the scene from memory.

Everything other than the street, however, is unreal. The blue-green horse standing on its hind legs is enormous, and the way its forelegs support the blue-faced fiddler reminds us of a human being holding a child. The large orange disk representing the sun also seems to be a dream element and, in the upper right corner, a tiny crescent moon sheds some extra light. An odd note of realism is struck by the tiny glints of orange in a window that seem intended as reflections of the setting sun. The children in the cart appear to be unconcerned about the antics of the horse or by the presence of the fiddler. In all probability, they see neither; they are glimpsed only by the perceptive inner eye of the painter.

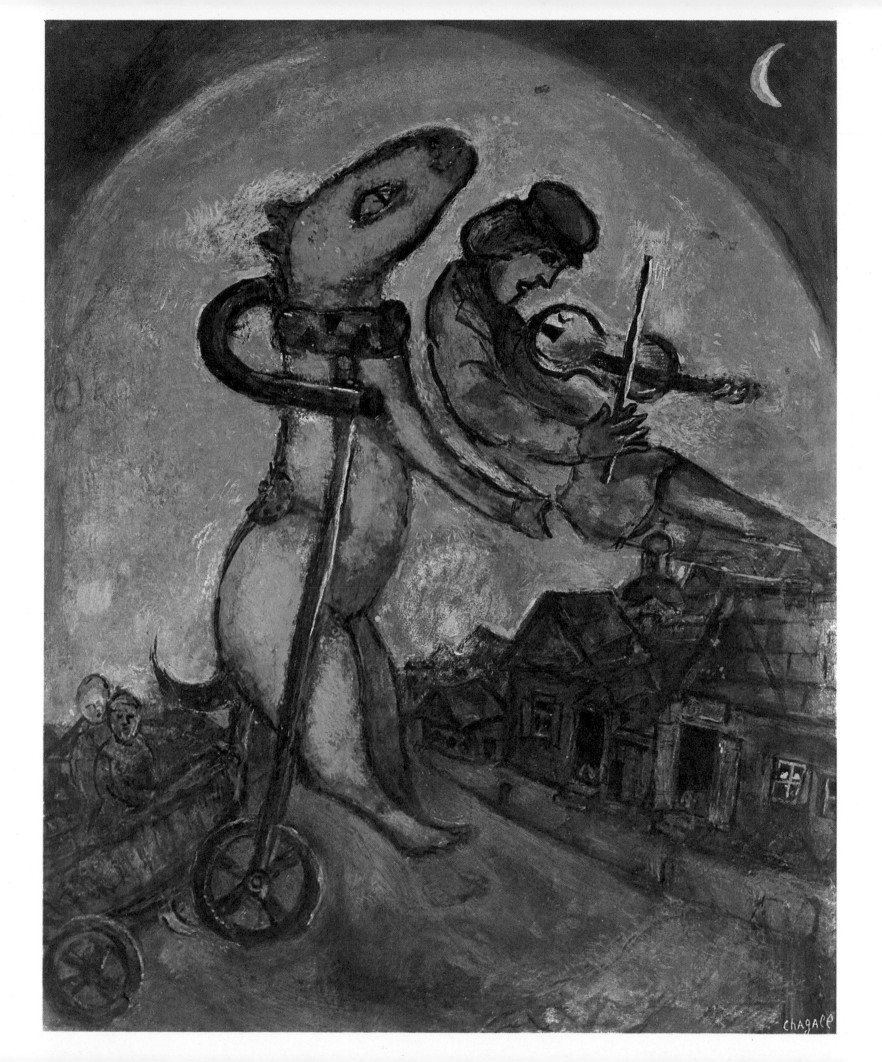

Plate 28
WOMAN AT WINDOW
1961
Watercolor
27½" x 21"
Acquavella Galleries, New York

In Chagall's Vitebsk, there were hardly any flowers to be seen, certainly not in the proletarian neighborhood where he grew up. They would have been a luxury. One can therefore understand his surprised enchantment when his fiancée, Bella, appeared at his door one day with a sheaf of blossoms: "In her arms, clasped to her breast, she held a huge bouquet of sorb sprays, cloudy green spangled with red." Offering thanks, he knew how "inadequate" his words were. In coming to France, Chagall had entered a nation of flower lovers. Pierre-Joseph Redouté, who had instructed Marie-Antoinette and, later, each of Napoleon's two wives in the art of flower painting, is beloved by the French as the "Raphael of Flowers." It was especially in the sunny south of France, on the Côte d'Azur, that Chagall discovered all the glory and delight of nature's jewels.

It is significant that in his early pictures Chagall used flowers only as accessories. In his painting of 1913, *Paris Through the Window* (Guggenheim Museum, New York), a bouquet of flowers appears almost inconspicuously on the chair seat. In *Ida at the Window* (Stedelijk Museum, Amsterdam), painted eleven years later, the flowers on the windowsill already play a prominent role beside the artist's young daughter. However, flowers completely dominate many of his later pictures. In this one, the young woman reading a book—perhaps love poems, to conjure up her lover's image above her—and the sketchy bluish scene merely glimpsed through the window panes provides the setting for the flowers.

For Chagall, flowers, as well as animals, are never objects of botanical or zoological interest; he does not necessarily know the names of the flowers he paints. "In me, gardens flourish, my flowers are invented," he wrote in a poem. This charmingly casual bouquet, which is the central expressive motif in the painting rather than an incidental accessory, recalls the sad fact that, along with his compatriot Oskar Kokoschka, Chagall is the last representative of a vanishing branch of art—that of flower painting.

This painting is the only one in a long series of window compositions in which there is a dreamer in the shallow foreground and deep space extending beyond the window. Unlike the Impressionists, Chagall never liked to work outdoors. This was true even of the young man: "I painted at my window," he wrote in *My Life*. "I never went out on the street with my paintbox." Through the device of the open window, the artist eliminates the boundaries between outdoors and indoors and weds distance to nearness.

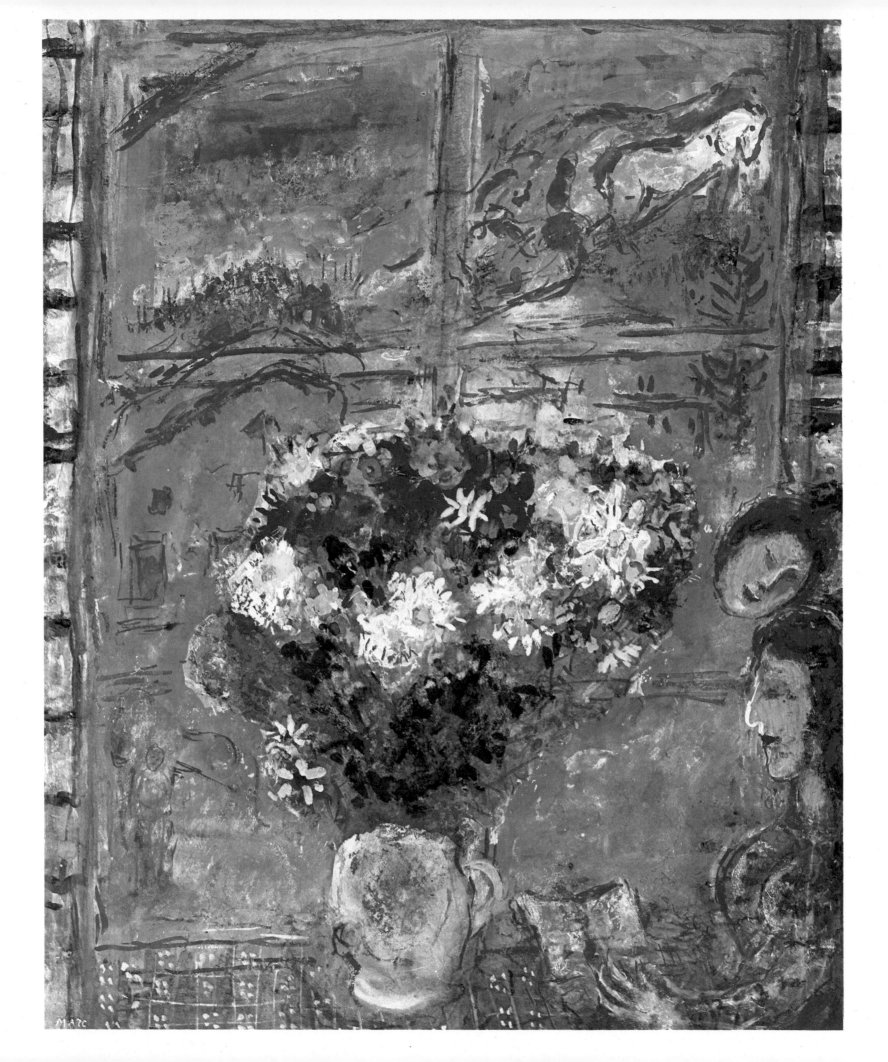

Plate 29
ANIMAL AND CLOWN
1964
Gouache
20″ x 26″
Pierre Matisse Gallery, New York

No zoologist would commission Chagall to illustrate textbooks, for the artist declares his independence of dull reality and renders his beasts just the way he wants them. Is this clumsy creature in the center a donkey? A clown is reclining on the animal's back. He wears trousers with a pattern similar to that of the bare-breasted girl's plaid skirt. She does not hold the bouquet—it is free-floating in the air—she only touches it with her fingertips. The clown's yellow jacket and the red flowers introduce the only warm accents into this rather stark composition. Note the two Russian timber houses in the lower left corner. (Is the figure in the doorway meant to be Marc Chagall as a boy and the scene a childhood memory?) More than forty years had intervened since Chagall's last stay in his native country. Still, the painting has a charm which could have been inspired by Chagall's nostalgia for his childhood and his native land.

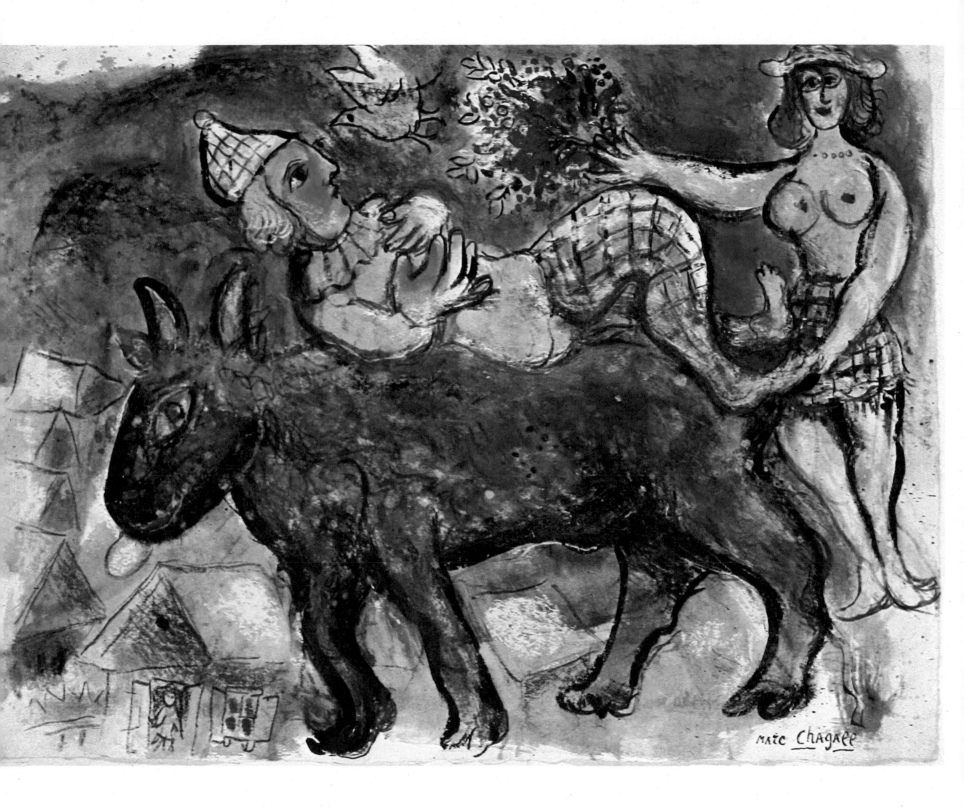

Plate 30
LOVERS IN THE NIGHT
1966
India ink and gouache
15⅗″ x 22″
Pierre Matisse Gallery, New York

Throughout Chagall's career works with the theme of lovers—embracing, gazing into each other's eyes, oblivious of the world around—occur again and again. This picture calls to mind Oskar Kokoschka's famous *Bride of the Wind* (1914, Kunstmuseum, Basel), which represents the artist and his beloved in somewhat similar positions. In both paintings the same nightly blue prevails. In the Austrian's picture, the lovers are carried by a hurricane, whereas in Chagall's gouache the atmosphere is peaceful and calm. Note the other elements—a woman carrying a basket on her head and on the bottom, the dim outlines of a town. Is the round form at the upper right a huge eyeball watching the embrace? Are there staring faces concealed in the clouds?

When Chagall painted this gouache he was close to eighty, but it is clear that he still thought ardently of fleshly love. Perhaps he was recalling in his mind's eye all the beautiful women he had seen, including the Mexican fruit-basket carrier who has slipped into a corner of the scene.

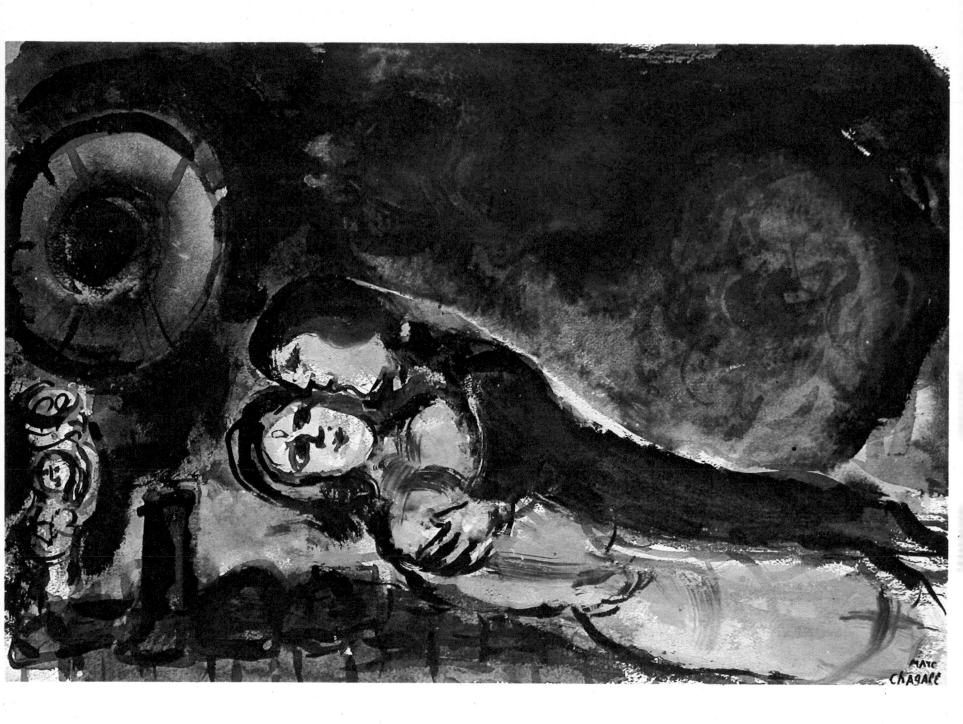

Plate 31
GREY NUDE
1967
Wash and watercolor
9¼″ x 12¼″
Pierre Matisse Gallery, New York

In this late picture, Chagall assembles many of the motifs that have appeared in his early work. The man carrying a bouquet of flowers to his beloved, the woman herself, as well as the huge rooster and the sun, all painted in the quasi-primitive way that resembles children's art, have been known to us for half a century or longer. The sun-moon relationship, with the black crescent of the moon placed in the white aura of the sun is interesting, though, and attracts our attention.

There is a completely new feature also in the introduction of a palm tree and, next to it, a southern town (perhaps St.-Paul-de-Vence where the Chagalls have been living since 1966). The man is holding the umbrella to protect himself against the strong Provençal sunshine, rather than against rain. The colors are low-keyed because of the use of gray wash with watercolor.

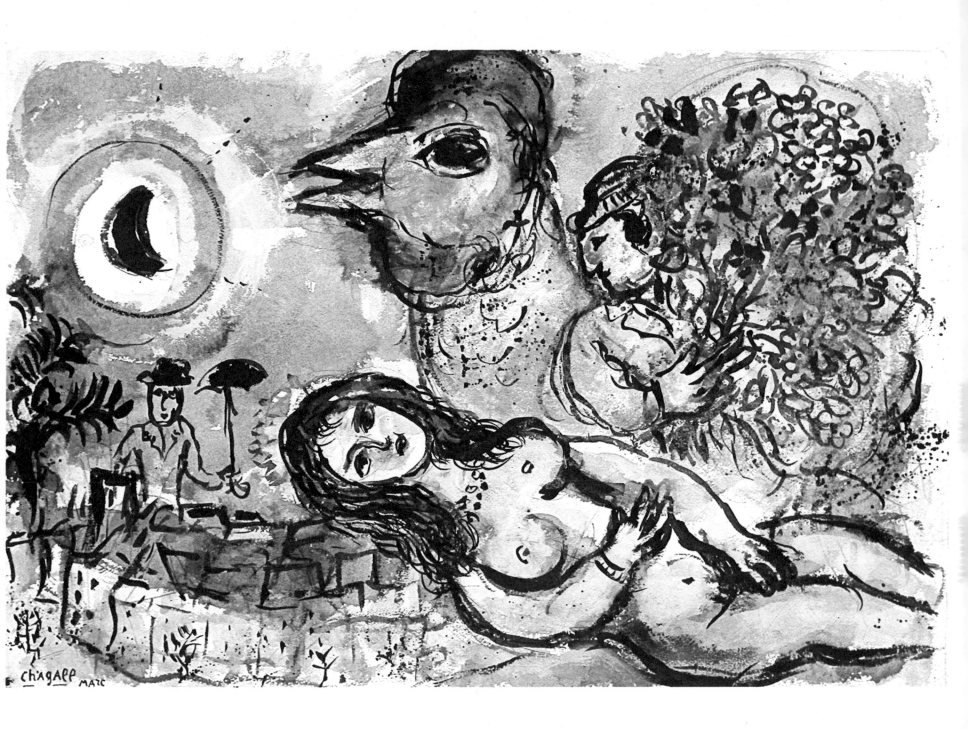

Plate 32
MOTHER AND CHILD
1968
Gouache
20″ x 13″
Pierre Matisse Gallery, New York

Mother and child seem to be rising out of the bouquet of flowers that frames the two and ties the picture together. Somehow, the stance of the woman is reminiscent of figures in Byzantine and Russian icons. The baby's head is symmetrical to the mother's breast in size and shape and seems to be symbolic of the child's dependence on its mother for food. The houses below accentuate the curve of the figure and its dominant position. The royal blue color which pervades the painting is, despite its name, a most ordinary color, yet in Chagall's hands it becomes something mysterious. Just imagine how changed this picture would be if the sky were red or green or yellow!

Despite his age—this picture was painted when he was eighty-two— Chagall retains his fantastic sense of composition. The artist is able to gather all the different elements successfully: the goat behind the mother, the woman carrying a basket, and the man—presumably her husband— placidly reclining with a rooster cradled in his arm. As Chagall grows older, the people he depicts in his paintings retain their youth, looking happy and without worry.

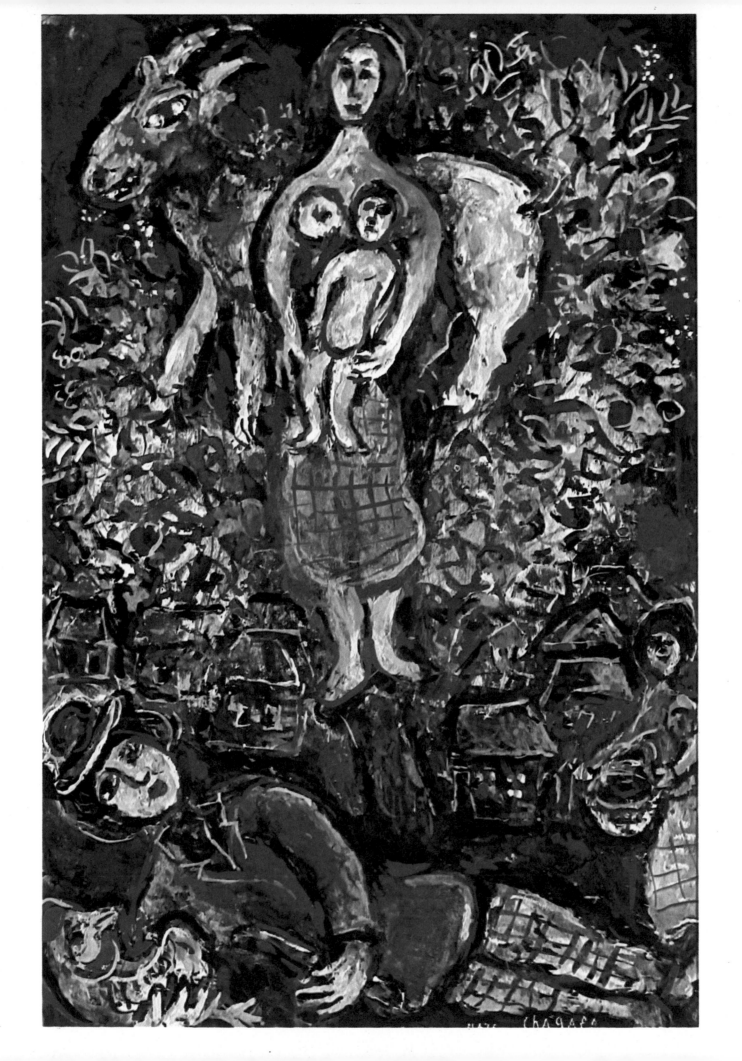

Edited By Heather Meredith

Designed By James Craig

Set in ten point Italian Garamond by York Typesetting Co. Inc.

Graphic Production by Frank De Luca

Printed and bound in Japan by Toppan Printing Company, Ltd.